Professional

PORTRAIT PHOTOGRAPHY

Techniques and Images from Master Photographers

Lou Jacobs Jr.

AMHERST MEDIA, INC. ■ BUFFALO, NY

Front cover photo by Frank Frost.
Back cover photo by Chris Nelson.

Published by:
Amherst Media, Inc.
P.O. Box 586
Buffalo, N.Y. 14226
Fax: 716-874-4508
www.AmherstMedia.com

Publisher: Craig Alesse
Senior Editor/Production Manager: Michelle Perkins
Assistant Editor: Barbara A. Lynch-Johnt
Editorial Assistance: Carey Maines and John S. Loder

ISBN-13: 978-1-58428-229-7
Library of Congress Control Number: 2007942649
Printed in Korea.
10 9 8 7 6 5 4 3 2 1

CONTENTS

INTRODUCTION

One of the first historic photographs on record is a time-exposed French street scene created in 1839. In the years that followed, imaging art and techniques quickly improved. A photograph I recall vividly is a group portrait of Lincoln and his generals, created by Mathew Brady, who operated a popular portrait studio in Washington, DC, in the 1860s. Professional portraits became more popular via daguerreotypes and tin-types. Poses required exposures of up to a minute. Glass plates were faster, but the processing required was clumsy. You may recall some of the portraits by prominent photographers of the 19th and early 20th century, including Julia Margaret Cameron, Alfred Stieglitz, Edward Steichen, August Sander, and George Hurrell.

In 1889, George Eastman introduced roll film, 100 exposures in a box camera that was sent to the factory for processing and reloading. The public began taking thousands of snapshots. Professionals graduated to sheet film and roll film. By the mid-20th century, portrait studios had sprung up everywhere to offer visual memories of children, families, and friends. Today's digital capture has made photography even more versatile. Portraiture was and still is a gratifying way to make a living.

Fine Portraiture

Like lasagna, not all portraits are created equally. I've ordered lasagna in restaurants from Florence, Italy, to San Francisco, CA, and each had its own flavor. Portraits may also have individual characteristics in today's market. As the images in this book show, the success of an image is largely due to individual tastes, talent, and techniques. A photographer's personality can also influence the aesthetic quality of portraits. Every photographer interviewed for this book agrees.

About Portrait Style

Snapshot portraits are mostly forgettable, though some amateur images can be terrific. However, professionals can't depend on happy accidents. We inspire expressions and moods, modulate lighting, and adjust composition

PHOTOGRAPH BY BETH FORESTER.

as we chat with our subjects. A professional photographer can create magic in portraits that clients happily pay for.

Portrait style is hard to define but easier to recognize. It's a mixture of creative seeing, artful lighting, a precise sense of timing, a good instinct for posing, and an attitude that strives to bring out the best in people. Mood is also created by lighting and expressions.

It's worth being influenced by portrait work you like in this book and everywhere you see it. Your own style can evolve to please clients and make you proud of producing fine portraits.

Movie Style. Director Ingmar Bergman said of Sven Nykvist, a great cinematographer, "He has been an inspiration for his natural, simple style of lighting. His work is extremely subtle. We were both utterly captivated by the problems of light." A *Los Angeles Times* editorial added, "Nykvist was a believer in the power of faces, often zooming in for intense . . . close-ups ("Death of a Swedish Realist," *Los Angeles Times,* September 22, 2006: B12)." Nykvist won Oscars for *JFK* and *The Aviator,* and also photographed *Sleepless in Seattle.*

Study cinema faces and magazine portraits. Decide if the photographer showed character as well as beauty. Experiment with friends who model for you, or use a mannequin. You will make discoveries that help you please more clients and increase profits.

Style is elusive. I often argue with myself and others about individual portrait styles. I feel that many successful professionals do not have recognizable pictorial styles, but they prosper. So does style matter? Yes, because if it emerges, it helps you develop portrait individuality. People skills also impact photographic style, as do handsome prints that generate repeat business. Success may not bring you a yacht, but it keeps your studio looking sharp and fuels your creativity.

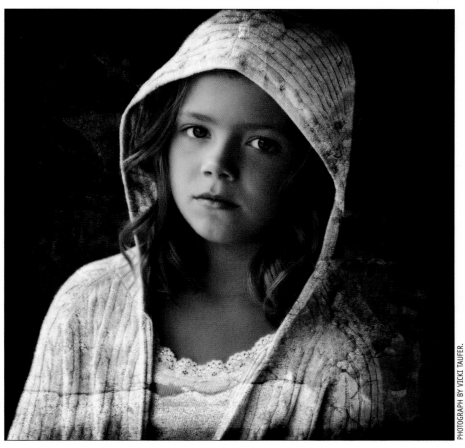

Why We Take Portraits

Portraits are made to please clients, relatives, friends, editors, advertising art directors, curators, and potential lovers. The portrait business is a stimulating way to make a living. Fine portraiture is a challenging form of creativity. People save your prints for generations to come, so be sure to put your name on your portraits.

Portrait Techniques

You and your clients should be a comfortable team for success. Anticipate how to make a subject look terrific, because or in spite of their personality, age, and appearance. Subtle or significant variations can be captured with slight changes in a pose, a camera angle, and/or lighting.

Jane Brown's portrait style evolves from clever ways to avoid using flash. She photographs celebrities for an English Sunday newspaper, almost all on location. Jane favors staircase settings because subjects can be placed above or below the camera, walls are usually plain, and window lighting is available. She shoots in a lot of gardens, too, and as is evident in her fascinating book, *Faces* (Collins and Brown, 2000), she charms her subjects.

Offbeat Portraiture

Beautiful people are not guaranteed. Though photogenic faces are always welcome, plain ones are often a challenge. Soft lighting, careful angles, and artful poses are cool solutions. Involve the handsome or the homely and you will reap rewards. Vary posing, lighting, or background options to increase your odds of photographic success. Offbeat subjects can amaze you.

Richard Avedon enjoyed a recognizable photographic style. He was an artist who often shot stark portraits of people staring pensively into the lens. He once took a white photo tent and an assistant on a trip around the United States, photographing often grim-faced subjects. I feel some of his images are depressing and static, but they are also riveting.

Celebrity shooter Annie Leibovitz has had a notable portrait career. Remember her pictures of a naked John Lennon curled around Yoko Ono? Or Demi Moore, nude and pregnant on the cover of *Vanity Fair?* You will find these and more in her book, *A Photographer's Life: 1980–1995* (Random House, 2006). Annie has a notable style and a flair for capturing subjects with humorous or offbeat attitudes.

It's healthy to seek the unconventional for print exhibitions and for some types of clients, to expand your vision. But beware of offbeat portraits made primarily to attract attention. I call them leg-pull art.

Personal Projects

"There is nothing more satisfying than taking pictures for yourself," says Steven H. Begleiter, author of *The Portrait Book: A Guide for Photographers* (Amherst Media, 2003). Steven advocates shooting portraits for your own pleasure, without thinking about pleasing a client. "It's a time for visual growth," he adds. "Find a theme and suitable subjects and let your intuition guide you. A collection of personal portraits with your signature style may encourage you to modify your other work." Steven's work and working habits are profiled in chapter 1.

In the mid-20th century, I undertook a personal series of environmental portraits of California artists in their studios. Two newspaper art critics suggested subjects, and a few artists recommended me to others. All twenty-five were patient as I shot 4x5-inch black & white film, with mostly ambient light. The series spread over a year, and

among my subjects were Man Ray (who then lived in Hollywood, CA) and Edward Weston (at home near Carmel, CA). Their images plus others have appeared in my books and exhibitions.

As You Read This Book

Each photograph in this book was made with a point of view about people (of various ages) and their personalities. Consider what you can learn from their examples. Eight photographers work from studios or their homes. Two, Josh Kessler and Steven Begleiter, are mainly editorial photographers who do portraits for publication. They all offer personal information and viewpoints, and their pictures are evidence of their enthusiastic expertise.

Big bucks depend on your skills, dedication, business acumen, self-esteem, and rapport with people. When tact and talent are paired, it's amazing how much cooperation you receive and how much some clients are willing to pay. Enjoy yourself!

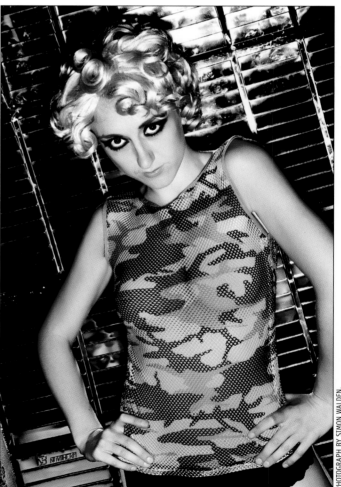

PHOTOGRAPH BY SIMON WALDEN.

1. STEVEN BEGLEITER

Steven Begleiter of Missoula, MT, has had a varied career. After studying photojournalism at Kent State he was a newspaper photographer, then an assistant for numerous New York photographers. He ran his own successful studio in New York and Philadelphia and has taught at seminars. He shot assignments for many magazines and corporate annual reports. Steven has also written and illustrated three books, including *The Portrait Book: A Guide for Photographers* (Amherst Media, 2003). In Philadelphia he taught at the University of Pennsylvania where students inspired him. In 2006, Steven, his wife, and children moved to Montana, where he is on the faculty of the Rocky Mountain School of Photography.

Describe your background.

I got hooked on photography at age fourteen when a friend with a darkroom showed me how to make prints. The rest of my career has been finding ways to make a living as a photographer. My degree from Kent State was in photojournalism and philosophy; the latter was very useful. I moved to New York City and learned more about commercial photography. My on-the-job skills included casting models, building sets, and collecting bills. Assisting Annie Leibovitz, I lugged heavy cases, met many celebrities, and sometimes worked seven days a week. I quit after a year over a salary dispute and was a sought-after freelance photo assistant with photographers like Mary Ellen Mark and Michael O'Brien. In 1982, I decided to open my own studio in New York City.

For almost twenty-five years I have specialized in portraiture, starting with a Fairchild Corporation trade publication. My first national magazine assignment came from *Forbes,* followed by *Business Week* and *Fortune.*

When my first book, *Fathers and Sons* (Abbeville Press, 1989), was published, I started getting assignments from *Esquire, Elle,* and *Us.* My pictures gave me exposure in the corporate photography world, and I began working for design firms on recruiting brochures and annual reports.

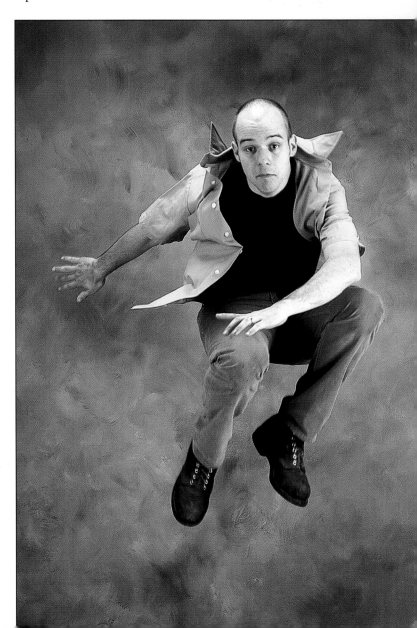

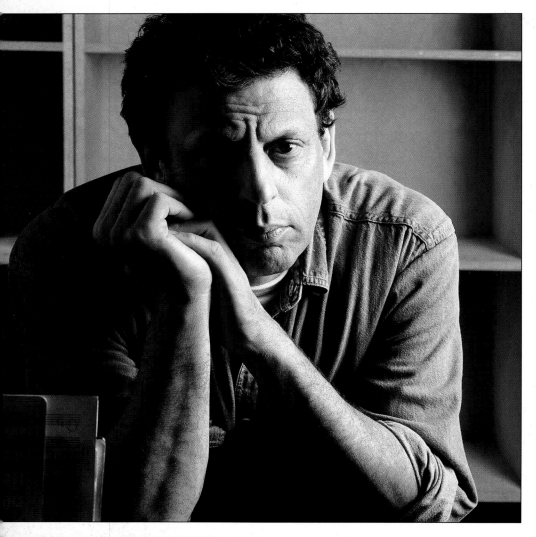

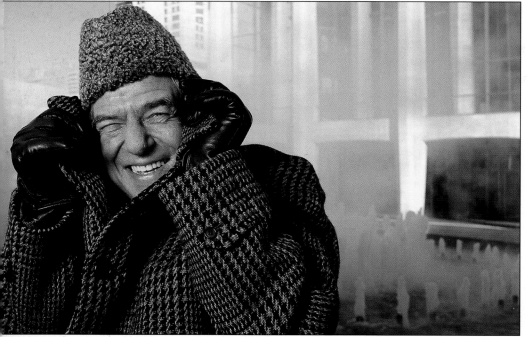

Who are your influences and mentors?

I have to say my biggest influence was Arnold Newman, and I have always been drawn to photographing people in their environments. My other hero is Irving Penn. He can transform any visual into an iconic image. Further influences include photographers, teachers, artists, and seminar speakers. Annie [Leibovitz] influenced the way I thought about taking portraits, such as to pick up a lot of information on my subject beforehand. Mary Ellen Mark taught me how to seek out the strong personalities in a photo essay. She also influenced my narrative style of photography.

Describe your studio.

Presently, I am converting my garage in Montana into a studio. In New York City I had three studios over fifteen years. The first was about 800 square feet, shared with another photographer. The next was a 3,000-square-foot studio in Soho, shared with a video company. My final studio, in the garment district, was also about 3,000 square feet, shared with two other photographers.

I always had a studio manager who was in charge of photo bookings, accounting, organizing photographs, and helping with promotions. We also hired freelance assistants. A studio is also handy for testing, and it offers more job opportunities. Now if I need studio space for a large shoot I will rent it. This may be for my convenience or because clients prefer it. I now employ an assistant about 90 percent of the time.

Do you have a philosophy that guides your approach to fine portraiture?

I feel a good portrait is just as much about the photographer as it is about the subject. I believe fine portraiture to be a mix of technical expertise and emotion during the shoot.

I also feel it's essential to shoot images for myself. It brings me back to reasons why I love photography. It also manifests visual ideas.

Rule of Thumb. According to a traditional guideline, the rectangle of a picture can be divided into nine equal segments [by imposing an imaginary tic-tac-toe grid over the image]. Placing the important element on or near an intersection of the lines helps create an image that emphasizes the subject and is more dynamic. To experiment, place a subject alternately at each intersection and decide what placement makes the most aesthetic sense. When you analyze portraits, consider the grid. Would you have composed the portrait the same way? Remember, portraits are not made by any one formula.

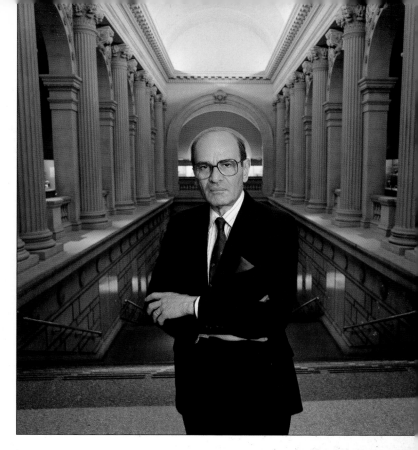

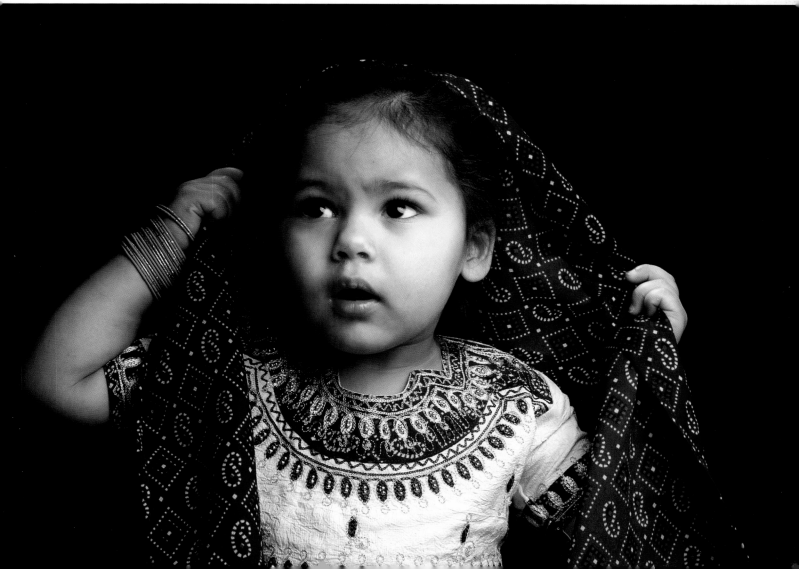

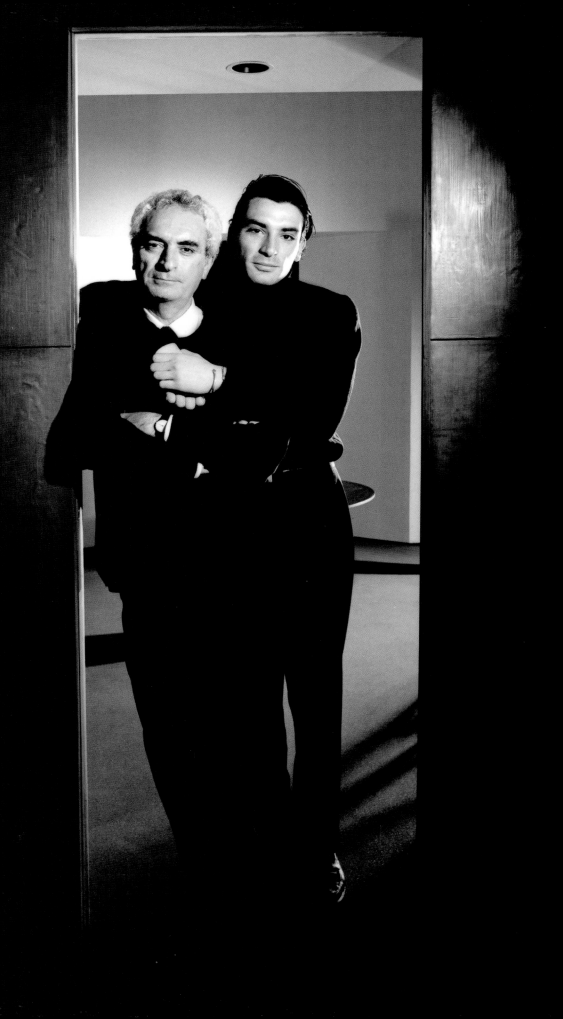

How do you approach your sessions?

My approach to sessions depends on whether I am shooting for myself or a private client. If it's a shoot for publication, I listen to the photo editor about the context of the portrait and learn something about the subject, then I shape my vision around the article's slant. Corporate annual report portraits are more about creating images that exhibit confidence and strength. Once I satisfy the client, and if there is time, I shoot for myself. I always try to capture what I perceive to be truthful portraits.

Describe your approach to scheduling.

Being a freelance photographer, I take jobs when they come. I try not to schedule more than three shoots a week, though I have had occasion to do as many as three shoots in a day. It's great when clients' needs and my time synchronize. I shoot when a job is confirmed and the time is open.

Were your early business expectations realistic?

I did not know what to expect when I got started. I tried to be in the moment and enjoyed the busy times. Promotion and personal projects were my most important business decisions early in my career. I started working on *Fathers and Sons* while I was an assistant. As a personal project it allowed me to stay creative while working for other photographers. When I stopped assisting I planned a marketing campaign of a series of promotional cards, follow-up calls, and appointments with my developing portfolio. My progress was emotional and technical. The more I shot, the more I learned about my capabilities and myself. I worried less and tried to be truer to my vision.

A Business Plan. It feels good to get paid to take portraits, but at the end of the month if your bills outweigh your invoices, it's time to reevaluate. Whatever your specialties, you need a plan that supports your goals to succeed professionally and make a profit. Figure your average monthly income (add your yearly gross and divide by twelve) and deduct your average fixed monthly overhead. Estimate up to a third of your income, depending on your specific circumstances, to cover federal, state, and local taxes. Add a percentage for insurance (your homeowner's policy may not cover your business), salaries, payments for supplies and equipment, rent, and maybe a retirement fund. Subtract the total overhead from your gross, and what's left is your profit. This advice is a general guideline.

If you are starting in business, it's wise to minimize your expenses, buy only the necessities, and see how your business progresses. Once you are established, you may be more elastic in what you spend, but be aware of your overhead. For more on this subject, see *The Portrait Book: A Guide for Photographers* (Amherst Media, 2003).

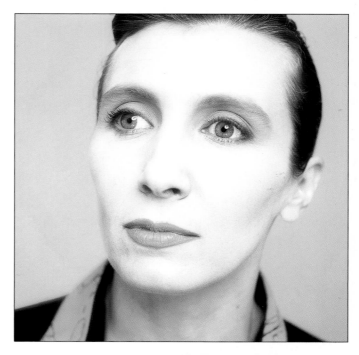

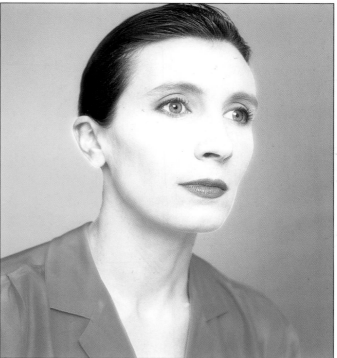

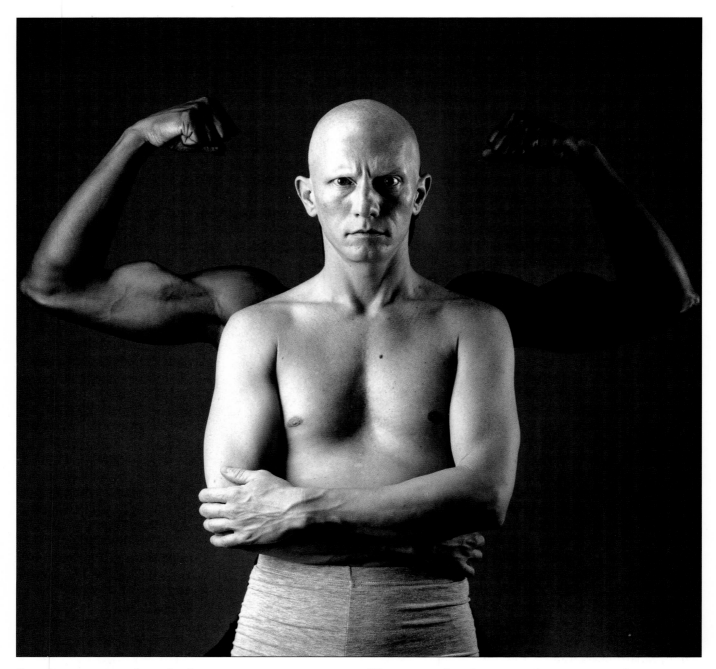

How do you approach posing?

I don't have any favorite poses, but I do like to have my subjects turn three-quarters to the camera. Posing really depends on the subject's physical characteristics. Is the image being made for the subject and his family or for publication? I really don't think that certain poses fit subject types such as young, older, beautiful, or handsome. Once I feel I have captured what the client expects I like to experiment. I try to shoot from experience and by instinct. It is all about observing what moves you viscerally and emotionally.

What strategies do you employ to communicate with your subjects and elicit the desired expressions from them?

I constantly talk to my subjects during a shoot. I want to engage with my subjects as if they are my best friends. Most subjects need to be distracted. I've found that the most successful sessions are the ones where the subject doesn't feel like he or she is being photographed. Again, instinct guides me in building rapport. Though I have read Jung and Freud, I have to say that empirical knowledge is my greatest teacher.

I try not to ask for smiles unless I am working with a professional model. I stimulate gestures and expressions through encouraging movements. When I encounter someone with a shy personality, I try to get closer. I might also shoot sequences because you never know when the unexpected portrait will be revealed.

There are a few other things to keep in mind to ensure the best-possible session:

1. Compliments should be realistic and sound sincere. Be friendly, but not too personal.
2. Unless you have a true comic gift, don't attempt a stand-up routine.
3. Avoid hot topics like politics and religion.
4. Try to encourage short responses to avoid too many open-mouthed shots.
5. Avoid talking very much about yourself unless you are encouraged to do so.

Which cameras and lenses do you prefer?

My primary camera used to be a Hasselblad with a 120mm macro lens, but since more of my work is now digital, I have been using a Canon 20D or 30D with a 105mm lens, a 28–135mm zoom, or a 20mm wide-angle lens.

What lighting equipment and approaches do you favor?

Lighting arrangements depend on the intent and final use of the image. I try to keep the lighting simple. The larger the area I need to cover, the larger the light source. To vary light-

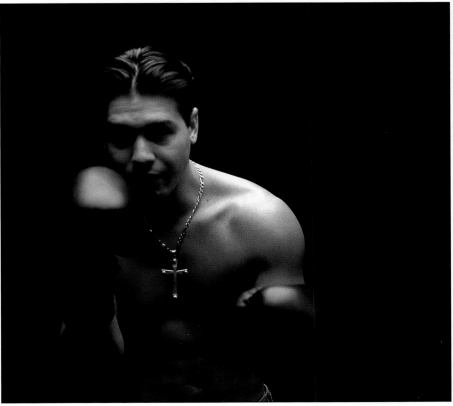

ing setups, I move the main light around to see how it shapes my subject. Charles Mingus, a great jazz musician, once said, "Anyone can make the simple complicated. Creativity is making the complicated simple."

Hard lighting is characterized by an abrupt falloff from highlight to shadow. It creates a strong modeling effect, emphasizing form and the facial outline or figure. This was typical of Hollywood glamour images of the '40s and '50s. Hard light is usually not diffused or modified. Spotlights and direct sunlight are typical hard light sources.

Soft lighting is characterized by a gradual transition from highlight to shadow. It tends to reveal the charac-

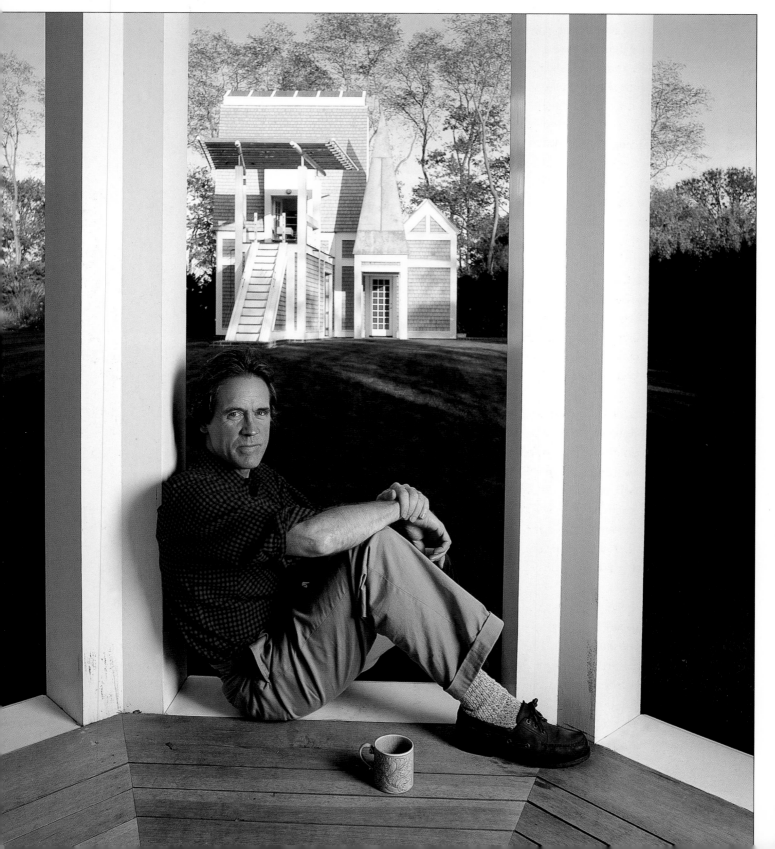

ter of the subject. In a gradual highlight-to-shadow transition, more midtones are created and more surface detail is captured. Larger light sources are usually used for soft lighting. Realize that a softbox or umbrella too large or too close to the subject produces few or no shadows. It's also important to remember that the light itself, not the bottom of the umbrella or softbox, should be slightly above the subject's eye level. Light from below a face may create a ghoulish or dangerous look.

Mood lighting creates more shadows and may hide part of the subject. Rembrandt or butterfly light is a good example, coupled with a high lighting ratio. Butterfly lighting is characteristically a narrow light, usually produced by a grid spot placed near the camera, a couple of feet above the subject's head. It creates a butterfly-shaped shadow underneath the subject's nose, narrowing the face. A fill light is sometimes placed behind the main light with an optional fill light opposite the main light. Add a strong hair light, and you create a popular 1940s lighting style.

Equipment. I have two 1200 Profoto power packs; one 2400 Profoto power pack; one 1200 Hensel Porty; small, medium, and large light banks; and umbrellas. I also use Canon EX flashes that complement the cameras. I use natural light in the studio if it looks good for portraits. My window configurations face northwest and provide even light in late day.

Hot lights (quartz) enable you to observe lighting changes as they happen. They are a great way to learn how moving lights can alter the form and appearance of your subject. You may practice on still life or a mannequin. Hot lighting systems are much less expensive than electronic flash units, and you won't need a separate strobe meter. However, many photographers reserve hot lights for still life rather than portraiture since they can become uncomfortably warm.

What type of backgrounds work best for you?

I use pull-down and canvas backdrops that are usually purchased, and I have created Jackson Pollack–like backdrops. As for props, I usually have chairs or other furniture handy that my subjects can lean on.

Do you conduct any location sessions?

I shoot outdoors often, at various locations. I prefer trop-

ical, exotic places, but sometimes an alley will do. Whether I shoot portraits in or out of the studio depends on the client's needs, weather, and time constraints. On location, I may use ambient light or flash.

Do you create environmental portraits?

We see these [environmental portraits] in magazines and newspapers, and I enjoy doing them in settings that help define the subject. They are about 80 percent of my business. Some subjects ask for them, or I may recommend them when I feel someone will be more comfortable in their own home or office.

Do you sell many black & white prints?

I love black & white, but most of my clients want color. I shoot my personal projects primarily in black & white. With the exception of the cover, my book *Fathers and Sons* was shot in black & white. My community projects are usually in black & white. I like the graphic quality and the freedom from color restrictions that shooting in black & white provides.

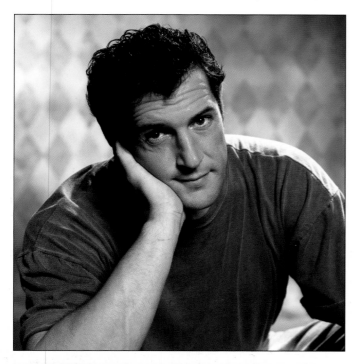

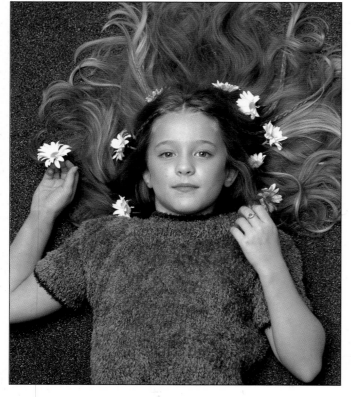

Describe your workflow.

I'm a bit of a control freak, so I do most postproduction work myself. Now that I'm pretty adept with digital, I'm having fun again. I put in a lot of effort upfront to come up with a great portrait, and there is nothing more disappointing than having it degraded in postproduction. My main printer is the Epson 1280.

How do you structure your pricing?

Pricing for me depends on the usage of the photographs. I license my images for specific types of reproduction. I am in the high-price category because of my experience and reputation, and I raise my prices every year to match inflation.

How do you promote your studio?

I promote my business though my web site, promotion cards, and cold calls. I employ a professional to maintain my web site, though I am considering switching to LiveBook service. I like prints, and I use my web site as a marketing tool. On occasion I have offered sittings for auction at charitable functions as a means of promotion.

How are your clients' images presented?

For presentation, I usually just show the client the good images.

Are there any business details you'd like to share?

I have created a five-year business plan about five times, each time with certain improvements. I put away a percentage of money from jobs for taxes, promotion, retirement, maintenance, and for the slow times. Most newcomers need help with their business plans.

How important is a photographer's personality to his or her success?

A photographer's personality is very important. That doesn't mean just being nice; it's more important to have a personality that can control the situation, plus the sensitivity to capture decisive moments. I do think that some portrait photographers may lose business because they don't communicate well.

Marcia Dolgin of Sharon, MA, says she has always aimed at artistry and craftsmanship in her work. She has had a long-time interest in portraiture arising from her study with artists and other professionals, especially when she worked with an assistant to Ansel Adams. She specializes in portraits of families, women, children, and high school seniors in the studio and on location.

Describe your background.

During my childhood in Vermont I used various creative mediums in my play activities. My grandfather was a well-known Massachusetts artist and designer who created custom wallpapers for exclusive theaters in Boston, and my father was a photo hobbyist.

I received my BA in Fine Art from the College of Fine Art at Boston University. It was a traditional program structured around German Expressionism. Launching any career in the arts with a studied background is forever valuable.

I started several successful graphic design businesses where I was the illustrator, designer, and/or art director. Those were the days of pens and straightedges. When my husband attended Stanford University to earn his graduate degree in engineering, I worked to support us. Be-

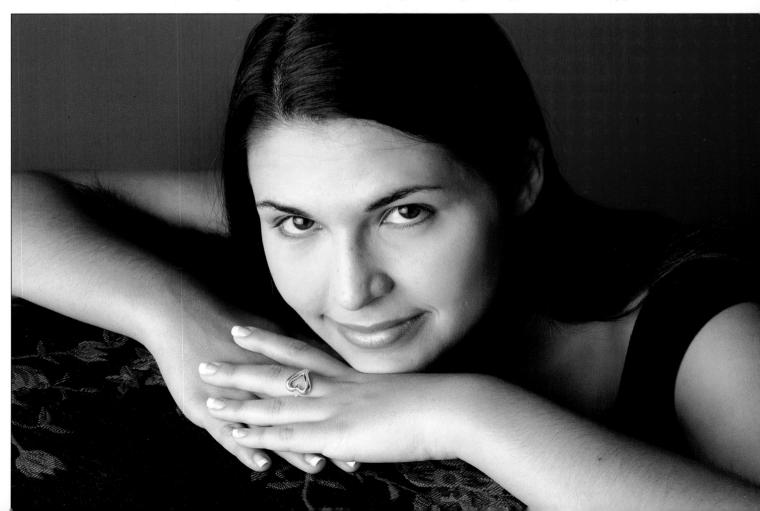

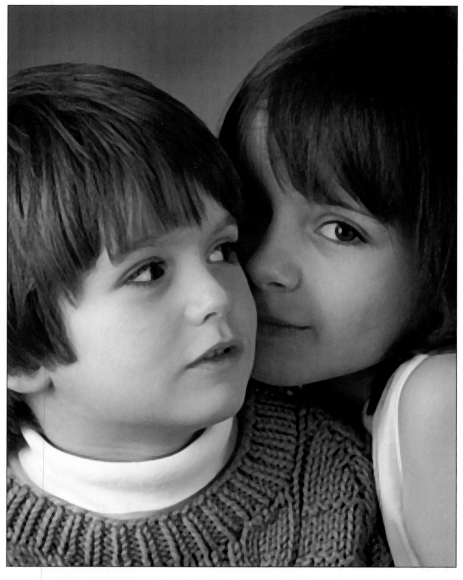

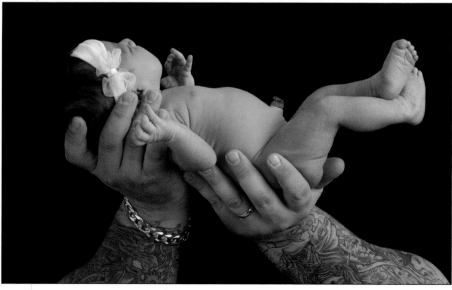

tween jobs I had an opportunity to study photography at Foothill Community College in Los Altos Hills, CA, thinking I could be creative during the week and still have my life.

I won a week at the Ansel Adams Workshop at Yosemite, and it was a powerful experience where I made incredible contacts. I realized how well the masters knew the techniques of their craft, and that they were dedicated and passionate to the point of personal sacrifice. Each believed in their own vision, and they could also communicate with others about their work.

I began my experience in large-format black & white photography. As a student, I was submerged in the darkroom during three years of working with Mr. Adams' assistants. I became a technical master but did not yet have my visual voice. Returning to Massachusetts, I freelanced in labs and later built a large-format darkroom for myself.

Fortunately, I was able to assist one of my mentors, Jenny Nourse of Jenny Nourse Photography, located in Canton, MA. She had just stepped down as president of Professional Photographers of America (PPA). I have since taken many courses, but in the digital realm I'm completely self-taught, starting a decade ago.

I've had my own business since 1987. I originally started photographing women only since that was my comfort ground. I made sure every image was gorgeous and made to suit my training in lighting and posing. Now I create artistic portraits of individual adults and children as well as families. I also occasionally shoot commercial work on the side.

Who are your influences and mentors?

Mr. Adams, Jenny Nourse, and others influenced my work. I also look at the Expressionist movement and paintings as my lead. Photography is a place of constant evolution for me. I am interested in dynamic movement and emotional connections as they apply to human relationships. I must keep in mind my clients' needs as well.

Describe your studio.

My present (second) studio is about 2,000 square feet, with the public areas decorated to look like the home of an upscale client. The layout is efficient, with a comfortable amount of open space where I create images in three out of four seasons. I also encourage clients to let us create portraits in their own home environment. I have three part-time employees to assist with a high level of service and framing, and one full-time operations manager to run the studio and relieve me of some administrative duties so I can focus on what I do best.

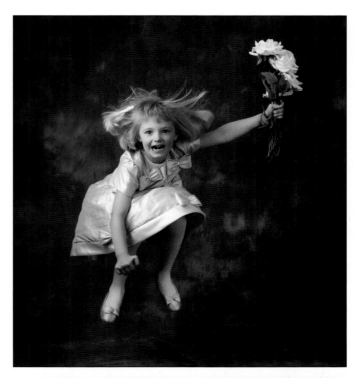

How do you approach your sessions?

I'm looking for a "truth" that is accurate at the moment it is imbedded in the image sensor. The result must be believable. How I accomplish this depends on the person, so I try to create positive, nonthreatening relationships. It's my job to allow subjects to trust me. I usually ask permission to fix their hair or shirt, to gently move into their personal space for a brief time. I don't patronize. I'm selectively truthful and tactful to give individual feedback to enhance our mutual understanding and to arrive at the core of believability. I try to be intuitive, though each individual responds to me uniquely. It's up to me to recognize those moments as they happen.

Do you have a philosophy that guides your approach to fine portraiture?

My style is recognizable but not easily repeatable, even for me. No two people are alike, and I look for a different level of connection with everyone. The results are portraits unique to the moment and the subjects. Many of my clients can tell a Dolgin print amongst others because of my style.

To me, fine portraiture means that the full technical aspects of lighting, design, emotional content, final output, and presentation have been fulfilled. The finished

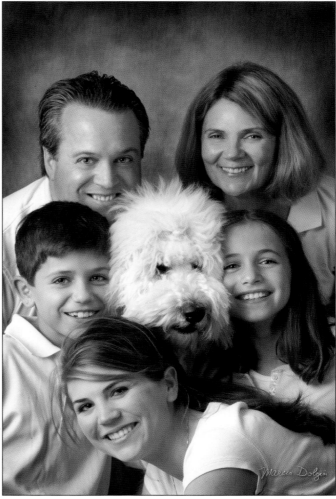

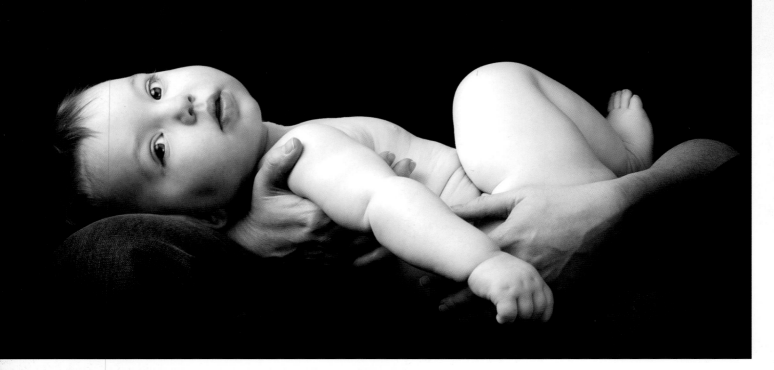

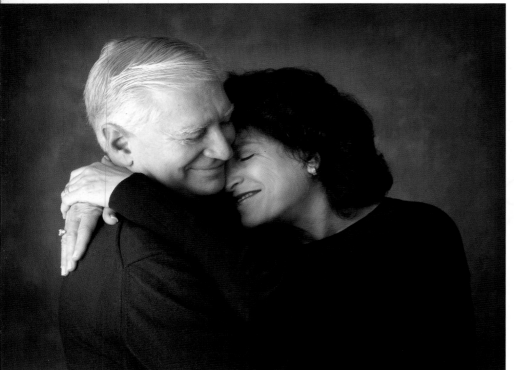

business and marketing. I only take children's' sessions in the mornings when the kids are fresh and offer me a few more minutes of childhood happiness. My goal is to have no more than four sessions per week. I edit and prepare the images for presentation (this takes about two hours, on average), which should take place one week later and is scheduled before the client leaves. I am the main creative artist in the studio. We have specialists such as a frame consultant and a custom holiday card consultant, and I am the coffee-table book design expert.

Were your early business expectations realistic?

My earliest expectations about the business were not realistic. I thought I would be working Monday through Friday from 9:00AM to 5:00PM. I learned the hard way and I'm almost there, twenty years later! I started only making portraits that were comfortable for me. I was reasonably sure that I knew what it was like to be a woman, and what most women want. So for several years, that's all that I photographed, and I became famous for it.

portrait should represent the best emotional and technical balance that the artist could achieve from the raw elements that gave the original image its soul.

Describe your approach to scheduling.

We schedule sessions Tuesday through Friday morning. Monday and Friday afternoons are reserved for studio

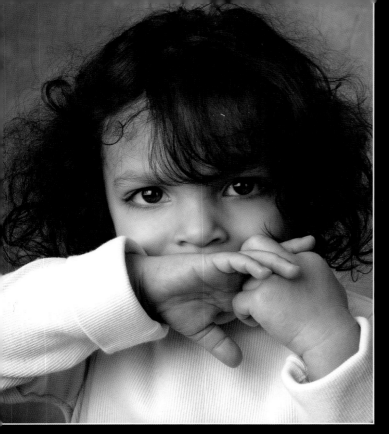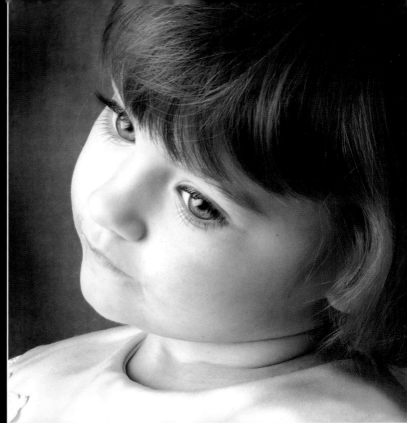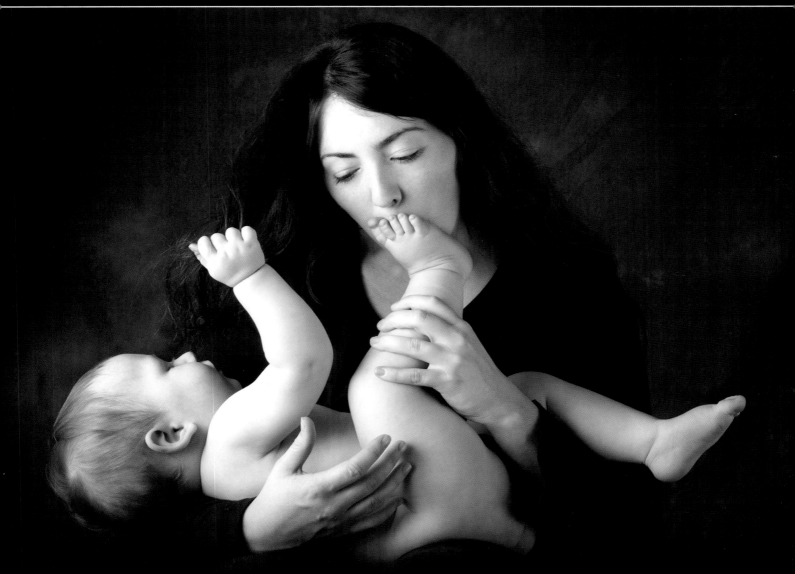

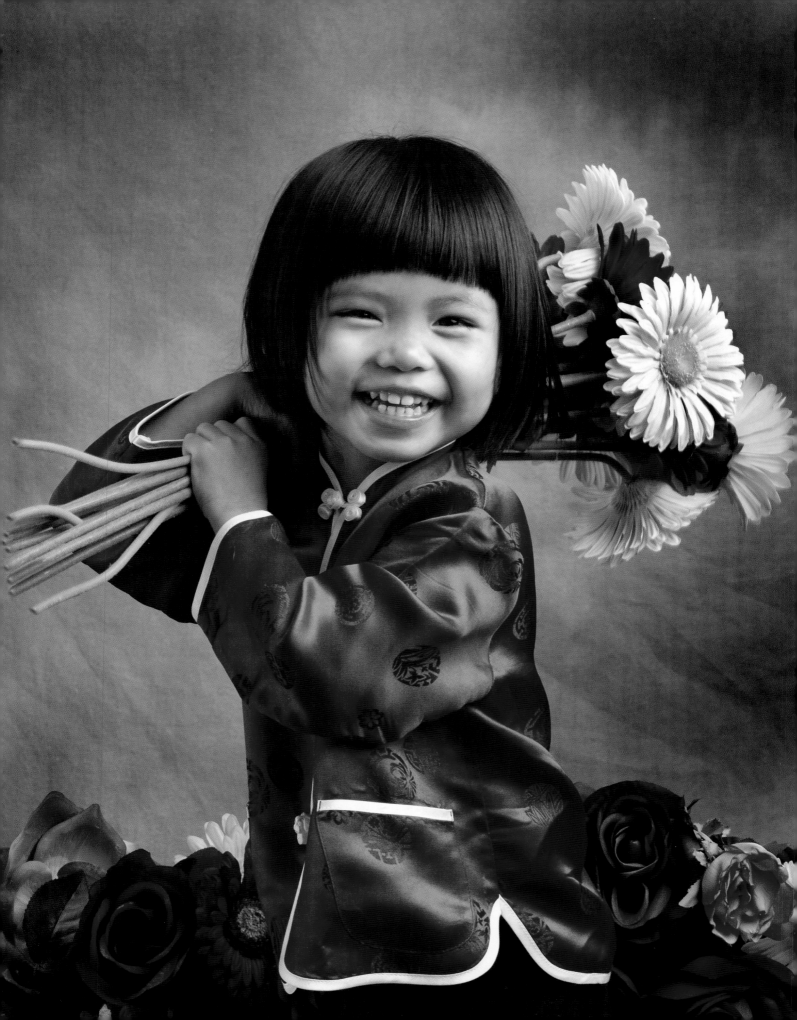

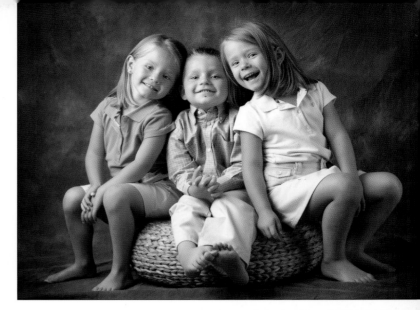

My past biggest handicaps were my limited emotional maturity and lack of courage to ask what I am worth, in terms of clients being happily invested in my work. Eventually I came to understand my value. At the same time, I continue to strive to be cutting edge in my technique and to grow in my visual maturity. This struggle has given me tremendous rewards.

How do you approach posing?
Each subject is unique. My experience with people has been very helpful and makes me more efficient. Posing seems to come to me naturally, but I do put a lot of effort into observations and insights as people move in their own space. I can combine the unique impressions I have of a person along with technical aspects I need to achieve my goal. Each person has a unique feature and, depending on the goal, I capitalize on whatever I need to attain my purpose.

Studying human faces and forms is very significant, and it can help you advance your comfort of "posing" and your sense of portraiture. I only pose people to get them started, but they quickly bring themselves to the forefront, giving me just what I'm looking for.

What strategies do you employ to communicate with your subjects and elicit the desired expressions?
I inform subjects of what I need from them before I begin. It's a chance to get their minds in sync with mine. It's amazing to see how people react to honesty and how powerful trust can be for the one hour we share.

I do not ask for smiles. If I can't get a natural smile, I just won't try for one. All I can do is treat the person well. They usually loosen up some before the session is over, and sometimes the best images are just around the corner. I always look for opportunities to create sequences, because they add to portrait potential and create additional income.

What lighting equipment and approaches do you favor?
I prefer a window-type light, using natural light or a single large light box with one large reflector placed nearby. I usually place the light box in the horizontal position. The edge that is closest to the background should line up perpendicularly with the client's position from the camera and be placed rather close to the subject. I use the

same type of light for couples as I do for individuals. Sometimes when I place the light source slightly off to the side, it's to slim a heavy person. I just pull the reflector away a bit. My advice is, take a look at the modeling light and let it tell you what to do. Mood lighting is produced when the lighting setup provides a little more contrast.

What type of backgrounds work best for you?

I have many muslin fabrics and only a few painted backgrounds. I try to have a collection appropriate for the many skin tones and hair colors I deal with. I use all kinds of fabrics, including tapestries, translucent fabrics, rich pillows, and throws; I occasionally use furniture. I tend to stay away from too many props in a portrait that can be distracting. That said, every rule is made to be broken with good learned judgment evolving from your style. Sometimes a subject's environment is an important bit of information that imparts a little insight into the person.

Do you conduct any location sessions?

We have unpredictable weather in New England, so winter is not usually a comfortable time for outdoor portraits. In pleasant weather I plan sessions in open shade areas with simple backgrounds. I often use a flash or reflector as a fill light or as a main light off camera, depending on the amount of action and the light ratios that exist at the location. I prefer to keep infants indoors and out of the sun. I use flash as a main light when the existing light isn't suitable. The quality of light impact is most important to keeping my goals intact.

Which cameras and lenses do you prefer?

I use the Canon EOS 1Ds Mark II, primarily with 70–200mm or a 35–70mm fast zoom lenses on location. This combination is excellent for

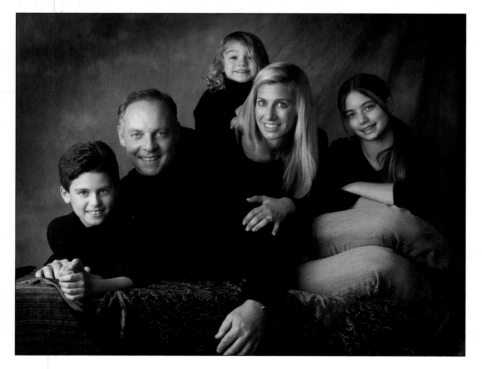

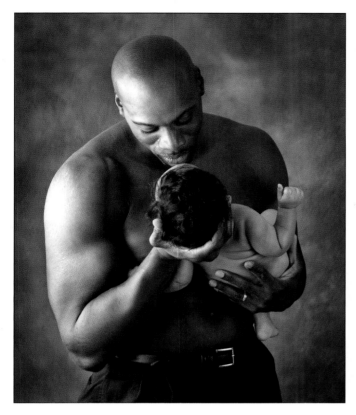

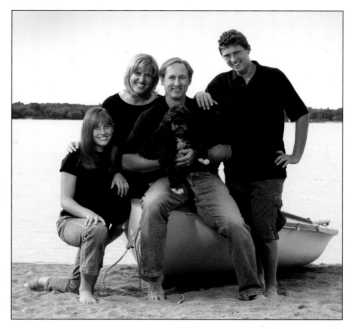

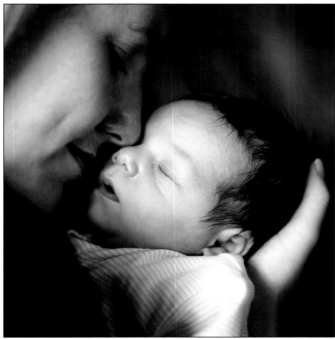

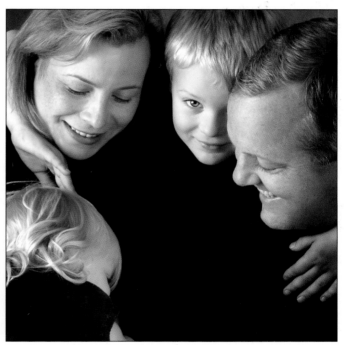

reminds me of my view camera days. The 80mm lens is equal to a 135mm lens at a 1:1 ratio. I have several lenses that I can use with the Phase One.

Do you sell many black & white prints?

Black & white portraiture is a major part of my business. It is particularly nice when my prints are as neutral as I desire. When we are presenting the images, I display some in black & white, color, sepia, and handcolored, when I feel clients may be open to each. Sometimes I display the

working with children and families since it offers a fast response time and a better range of ISOs and shutter speeds. I also like using my Phase One H20 digital back mounted on a Hasselblad 500CM body with a Carl Zeiss 80mm lens. I generally use it handheld in the studio for better mobility. Medium format with exceptional quality

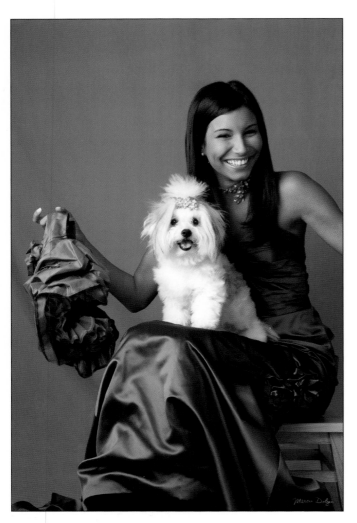

same image in black & white and in color to show the difference. Other times I display only what I feel is best. Some images are more compelling in black & white. Color, and the absence of it, is an element that shouldn't be abused. My clients are quite aware of their options.

Describe your workflow.

I edit, enhance, and print my images in-house using fine archival papers. I use inkjet inks with the most powerful RIP to give me the best prints possible. Having full control allows me to make far better prints than any outside source can produce. I have a greater knowledge base than most of my competition, and it quickly becomes obvious. My work is the sum total of all of my knowledge and experience. Since my company uses my name, I feel an obligation to do my best.

How are your clients' images presented?

I use a digital projection system to present a body of work that has been carefully edited and enhanced. There is nothing like projection to achieve higher sales. The impact of projection is more pronounced than a small proof or contact sheet. When an image is seen in a darkened room, it surrounds the client and becomes part of their environment. The value of what the viewer sees is much greater, since they experience it instead of just looking at

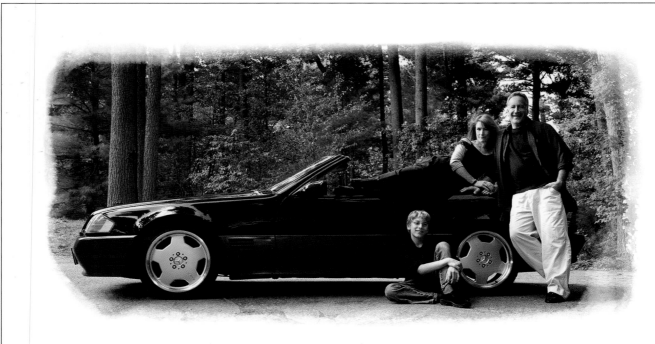

it. It's convincing, undiluted, and closer to what a portrait would look like on their wall or in a gallery. Your profits will skyrocket when the emotional impact of your portraits is embraced by the investing client.

The homey front room of our studio is designed for client [image] reviews. It includes a 56x48-inch white screen in a beautiful frame across one wall and framed portraits on the other walls. Two comfortable leather chairs face the projection screen, separated by a table for the projector and computer. We prefer that only portrait purchasers attend the review sessions, and I may reschedule if children or pets cause distractions. My operations manager handles most review sessions, freeing me up to concentrate on creative work and printing.

We create our own albums using blank adhesive styles manufactured outside of the studio.

How do you structure your pricing?
We do not sell packages. I found that approach works well when a studio is volume oriented but doesn't suit a

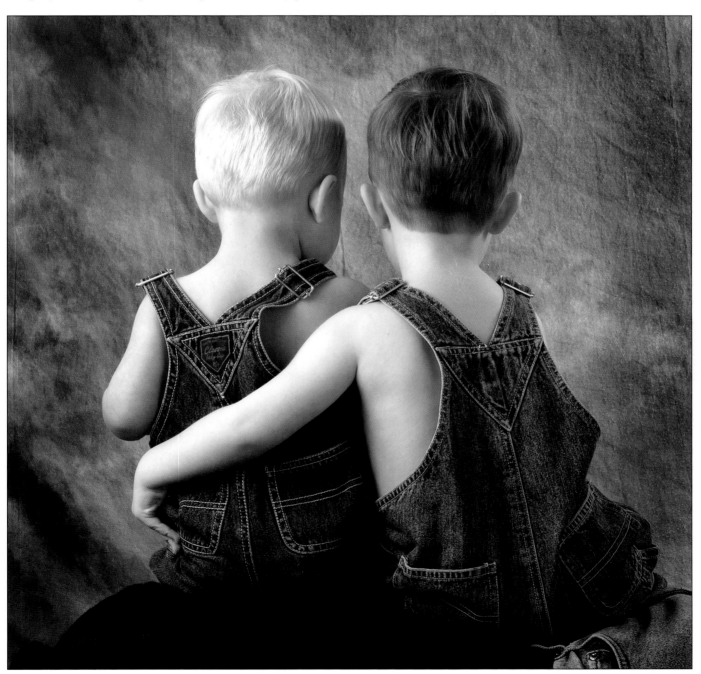

service-oriented studio. I raise my prices three times per year—on October 1st, December 1st, and July 4th. Prices return to the October level in January, and the cycle starts again. Our most popular print is the 24-inch size.

How do you promote your studio?

We use specialty newspapers and magazines respected by parents, plus other publications geared toward families. Sittings are auctioned at charitable fund-raisers. We try to rotate displays and galleries in public locations such as restaurants, coffee shops, high-end hair salons, bookstores, and art galleries. Some events include a "meet the artist" open house for current clients, who are encour-

aged to bring a friend. We send out newsletters three times a year and mail promo postcards for reprints and reminders about upcoming events and holiday deadlines. We maintain our studio's web site, but it is hosted by another organization.

Are there any business details you'd like to share?

The Small Business Association (SBA) will help a new business to develop a useful business plan as a free service. More information can be found at the SBA's web site. Go to www.sba.gov.

I did not pay myself a salary for many years because I was a DBA. Now I'm an S Corporation and I'm required to give myself a salary.

How important is a photographer's personality to his or her success?

A photographer's personality is vital to his or her success. I need to protect client relationships so my clients trust me. I can't bring up personal issues that may distress people. My goal is to make my clients comfortable enough to let me in, so I know what their expectations are and can exceed their expectations.

You are the sum total of all of your experiences and desires. Your attitude about life and people and your work become a part of your communication as an artist and photographer. You are responsible for your work. In the start-up phase, your work will reveal what you do and don't know. As you progress, you will have more knowledge and potential artistic control to truly express your vision.

3. BETH FORESTER

Beth Forester of Madison, WV, developed an interest in photography in 1990 when her daughter Katherine was born. Five years later, her hobby became a portrait studio that is quite successful. Beth has three times been named West Virginia Photographer of the Year (2004, 2006, and 2007) and has twice been named Mid-East Photographer of the Year (2006 and 2007). Her work has been accepted into PPA's Loan Collection. To learn nore, visit www.foresterphoto.com.

Describe your background.

I have a BA in history from Centre College in Kentucky where I majored in secondary education, although I've never taught school. In my 20s when Katherine was born, I shot black & white as an outlet for my creativity as a stay-at-home mom. In school, I excelled in both art and math, so I think digital photography has become a perfect fit.

Describe your business plan.

Since starting my studio twelve years ago, the business has always pushed further than my dreams. I have never had time to create a business plan or even to think, "Where do I want this business to be in five years?" Initially, I only wanted to photograph families and children, but client demands pushed me to include high school seniors and weddings. My time is divided: 50–60 percent seniors, 30 percent basic portraiture, and 10 percent weddings.

Fortunately, I have made good decisions, and I earn a nice living. I don't consider myself a savvy businessper-

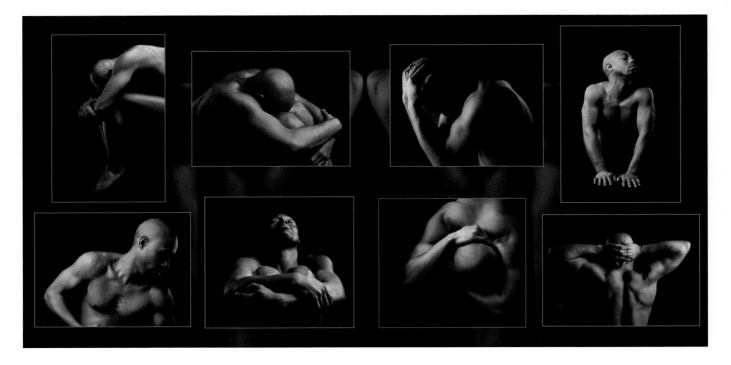

son, just a hard worker who happens to be a perfectionist.

What influences inspire your work?
I am constantly looking at images in magazines, books, television, or cinema. I am a huge movie buff, and a lot of the imagery in my head comes from movie portrait stills. It's the human element that draws me to portraits. I am definitely a people watcher, interested in psychology, how different types of people are portrayed, and how their personalities are revealed.

Describe your studio.
I rent a studio approximately 1,700 square feet in size, and half of that is the shooting area. There is a waiting area, an order taking room, a computer work area, a framing room, a changing area, and storage space. This is my third studio. My first was at home, though I shot mostly outdoors during that phase. I then moved into an old downtown building, and my studio was only open by appointment. I worked alone and had an answering machine. That studio had a nice display window, which helped immensely in getting new business.

Five years ago I moved into a building the owner was gutting. He let me lay out my studio, which has a hip but classic style. A lot of my personal photos and concert memorabilia are displayed in the shooting room, where people enjoy peeking into my life. It helps them to be more relaxed if they know a little about me.

I currently have two full-time employees. One takes care of proof

preparation, retouching, and general management. The other books appointments, downloads data backup, and does framing. They both take client orders, and sales have dramatically increased since they began working on commission. I generally do not shoot in the studio with an assistant, though I take one to weddings.

How do you approach your sessions?
I try to inspire emotion in my portrait subjects to evoke viewers' feelings, though it can be difficult because some subjects are not as inspirational as others. However, each day in the studio I try to bring the same enthusiasm and work ethic to every session. I want to feel that I give 110 percent to every client. I would want the same from anyone else I was commissioning to take my portrait.

I think most photographers, including me, have a certain style when we create images. However, I am constantly looking for new inspiration in the world around me to incorporate into my work. I want to feel I am growing as an artist and that with each new portrait I progress in my craft.

Since I started shooting digitally I have reduced my number of weekly sessions. Much of what I want to accomplish is done after image capture when I spend a lot of time color-correcting, editing, and retouching to give my work a more personal edge. For every hour I spend in the studio, I spend an hour on the computer. I know that I am a perfectionist, but every image reflects on my ability.

Personal Work. I really feel that personal work is an important part of the creative process. Each year when working on my competition prints, I can see my growth as an artist. I wish I had more time to create work simply to advance my creativity and style, but most of my time is devoted to business.

Do you have a philosophy that guides your approach to fine portraiture?
I feel that fine portraiture is work that in even fifty years will still move viewers to want to know or understand the portrait subject. I try my best to portray peoples' best impressions and moods. Because people are generally critical of themselves, I try to create images that please them. I work to hide flaws and enhance beauty, hoping subjects will think, "Wow, I look amazing!"

How do you approach posing?

I guess my favorite poses are those that seem to fit certain types of people. Poses are usually based on physical traits, and I modify posing to fit the subject's proportions. You will find that many poses just don't fit everyone, which also applies to lighting that needs to be modified a little for each subject. I shoot rather like I cook: I know the basics and I work on the rest until it looks right. A lot of instinct is involved in creating portraits.

What strategies do you employ to communicate with your subjects and elicit the desired expressions from them?

I have an ability to "size up" people fairly quickly. I talk a lot during sessions, to help people relax and get to know them better. Connecting helps them to assume more natural poses. College psychology has helped me considerably throughout my adult life, as a mother, wife, friend, businesswoman, and photographer. My interest in human nature and personality is a welcome asset.

I don't encourage big portrait smiles. Eyes are the most important aspect of a photograph because they

Were your early business expectations realistic?

I had no real expectations, but I have achieved far beyond my hopes. It wasn't just dumb luck. Hard work and maybe a little stubbornness have helped my progress. If the light is not perfect or the pose isn't perfect, I won't take the shot. I work about seventy hours a week—thirty-five in-studio and thirty-five on the computer. I do not believe in failure. I've rarely been in debt and didn't buy what I didn't need. I built up my business gradually and reinvest a portion of my profits into it yearly.

draw you into the image. Peoples' eyes are proverbially the windows to their souls. Smiles may distort their eyes, but most mothers want smiles to see their children as happy, so I oblige. Ninety-five percent of my clientele are mothers, so it is sensible to make their families and children appealing. However, expressions depend on the subjects and what type of mood I want to project in their photographs.

I do like to shoot sequential images, but they usually only work with children. You never know what to expect from kids, so a sequence helps prepare you for surprises.

What lighting equipment and approaches do you favor?
I generally use a four-light setup: a main light, fill light, background light, and a hair light. Sometimes for an extreme low key "mood" portrait I use a reflector instead

of a fill light. For individuals, couples, or groups I adjust the distance of the main softbox to the subjects. I use Photogenic PowerLights and Larson Soff Boxes. I find that various softboxes photograph differently, offering variations on warm light.

What type of backgrounds work best for you?

I like for images to emphasize the subject, so I only use props to enhance the story or the subject matter. Permanent sets in my studio fill all the wall space. I use a pulley system to raise and lower canvas backgrounds. I have picked up most of the backgrounds and props at antique or home decorating stores. I avoid anything that looks fake.

Do you conduct any location sessions?

I often shoot outdoors and usually choose among many potential locations based on the subject's clothing and their wishes. I also recommend

several favorite spots and arrange the shooting schedule to ensure sweet light according to seasonal changes. About the only time I use fill flash outdoors is when I am pulled to a location not of my choosing, and flash is the only option for light balance. Certain locations, such as streets or alleys, are primarily for senior portraits.

Do you create environmental portraits?

I wish I had the time to do environmental portraits, because I love them. I have done a few as commercial jobs, but they are not profitable or practical in a small West Virginia town where I cannot charge a day's work for one or two images. I feel like I learn a little more about my craft doing environmental portraits, but it's just not economical.

Which cameras and lenses do you prefer?

I use two digital Kodak Pro SLR cameras that are currently discontinued. I've tried so many cameras and have not been satisfied with their range in the midtone/skin areas. My favorite lens is a Tamron f/2.8 28–105mm for 95 percent of my portrait work. I use several other lenses for weddings.

Do you sell many black & white prints?

When I first started, I shot primarily T-Max black & white film, and I learned the advantages of proper exposure, contrast, and composition. In past art classes, I was drawn to and excelled in monochromatic images done with either pencil or pen and ink. My style often leans toward monochromatic imagery, and I may choose a background in the same tonal range as the subject's clothing.

When I started shooting digitally, I moved away from black & white. I still prefer it, but I shoot 80 percent in color—for one reason, because I found it fascinating to color correct my work by using layer masks and selections. I spent a grueling year teaching myself to see color and to make appropriate changes for a quality image. Now I have gratifying control and precision.

Describe your workflow.

Enhancing, color correcting, and retouching all my images for final output puts a personal stamp on my product. In film days, creativity was mainly capturing the image. Now creativity has been expanded, and I can make images look the way I envisioned them. I was very fortunate when I moved into digital in that my husband owns a professional lab and has been a great instructor on how to create a custom print. I have improved tremendously as a photographer with his support and knowledge. Many things I learned in digital processing helped me to improve my craft in the studio.

Before taking any images we show a catalog of digitally enhanced por-

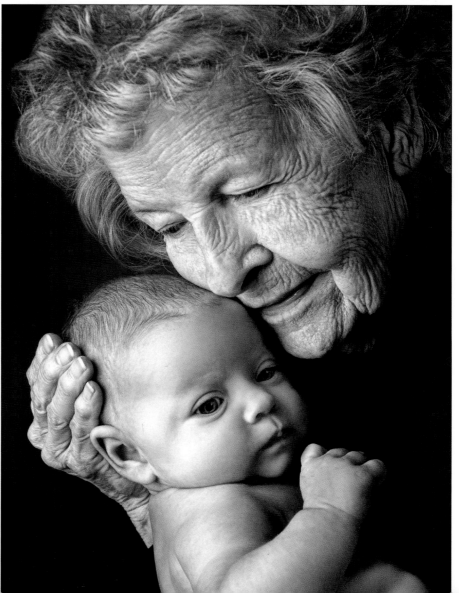

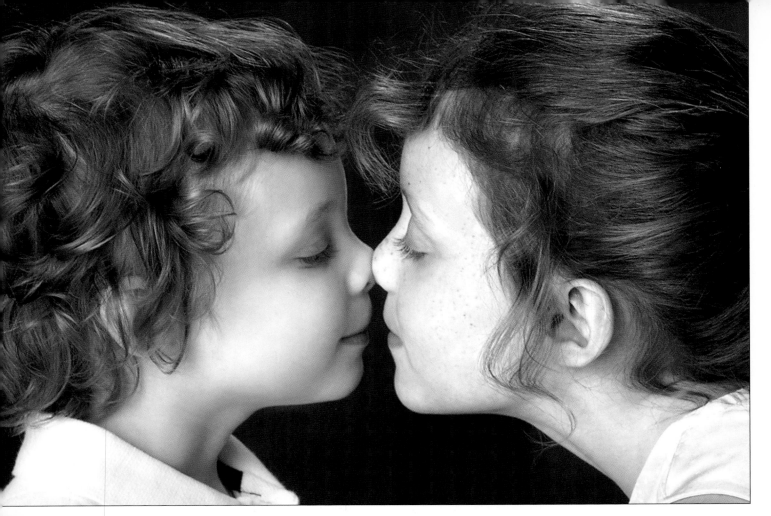

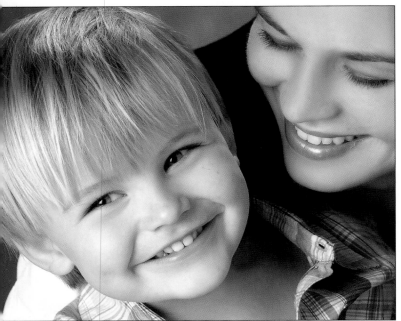

not based on templates. Because these artistic improvements are created "on the fly," each subject's images will be slightly different than those of other clients, though created with the same effect.

I have tried to paint the exact same picture twice, but each painting had slightly different brush strokes or color harmony, so exact duplication was elusive. It's the same with computer enhancements. Each image will look different day to day and subject to subject, though the same effects are applied to different images.

All of our prints are made at my husband's pro lab on photographic paper using a Fuji Frontier printer, up to 10x15 inches, and a Durst Epsilon printer for up to 30 inches wide.

How are your clients' images presented?
Paper proofs, 3.5x5 inches with a logo in the lower-right corner, work best in our studio. We tried digital contact sheets and booklets, but our sales were flat. We returned to paper proofs with newly designed packages, and within a year our sales nearly doubled. Each package includes a

traits to clients. Enhancements are priced from $5.00 to $75.00 and are quite popular with my clientele, who are shown how the enhancements can make their photographs more unique. We explain that this is custom work,

specific number of proofs. As the price of the package increases, so does the number of proofs. We have five package levels, and with the fifth level the customer receives all of their session proofs. Each year we increase the price of the fifth level and find that a minimum of 75 percent of our customers purchase it anyway. About half of those add framing and specialty products that are not included in our packages. Our sales are very satisfying, and my sessions stay booked three to four months in advance.

How do you structure your pricing?

Madison's population is only 3,000, but I draw clients from three counties, and I am probably the highest-priced studio in the whole area. We raise prices and redesign our packages every year. I try to set up the packages to encourage customers to purchase specific items, but not very large prints. The larger the print, the more time I spend retouching the file, so 24x30s and larger are more stressful and not that much more profitable. Proofs increase our profits and encourage customers to purchase larger packages.

The incentive program I offer my two employees has also increased sales. I devised a tiered system. As sales in-

crease from 1 to 10 percent, commissions increase, beginning at the $500.00 sales level. Staff morale has increased as well, and employees are motivated to offer new products and come up with new ideas that could boost their incomes.

Our senior and wedding albums are not created using templates. Each is a freestyle design.

How do you promote your studio?

I have no time for self-promotion. We found that by the time we might have promoted a special or an upcoming senior portrait season, my calendar was already booked four months ahead. In early 2007, I had twenty to thirty seniors with prepaid appointments for the 2008 graduation class. I didn't finish shooting the 2007 seniors until March.

I would like to do more charitable work in the future. Presently I have a sixteen-year-old daughter who I plan to send to a college of her choice, so maintaining my current level of income is vital. In about five or six years I hope to spend time shooting for myself and for specific charitable organizations. I really want to take my specific abilities and use them to give something back to society.

How important is a photographer's personality to his or her success?

I feel it is advantageous to be a woman in this field, because 95 percent of our clients are women as subjects or mothers. I also feel that most senior girls prefer being photographed by a woman. They are more comfortable if I fix their hair or clothing. I think that men find it uncomfortable to be touched by another man, so I'm more welcome. When working with children, being a mother myself, women may feel I more quickly understand that they want the photographs to reflect the personality and beauty of their children.

Because I dislike being scrutinized and photographed, I do everything in my power to put portrait subjects at ease. So I do feel that personality plays a large role in a photographer's success.

4. FRANK FROST

Frank Frost of Albuquerque, NM, discovered his fascination with photography as a junior high student. At age sixteen he was technically proficient enough to photograph his first wedding. After graduating from high school he worked at McDonalds. At age nineteen, he was McDonalds' youngest manager in the Southwest. Knowing he wanted to be a photographer, he shot pictures in his spare time and saved up money to buy a mom-and-pop studio. Today, Frank runs a thriving business in a deluxe studio. To learn more about frank, please visit www.frankfrost.com.

Describe your background.

I've been in business since 1982 and consider myself a people rather than portrait photographer. I enjoy the human element and could never be happy shooting inanimate objects. The first two years of my business were spent part time. I managed a McDonalds and worked at the studio on the side. In 1984, I took the plunge into full-time photography. Today, we photograph families (40 percent), seniors (30 percent), children (15 percent), and weddings (15 percent).

Who are your influences and mentors?

Unfortunately, I never had a mentor, but I have admired the work of countless photographers. I've taken practical and aesthetic bits and pieces from a lot of people over the years and made them my own. However, I don't believe in trying to emulate someone else's style. In business

and philosophy Zig Ziglar, Charles (Chuckie) Lewis, Dale Carnegie, and Norman Vincent Peale are among those who inspired and helped educate me.

Describe your studio.

My studio for the past four years has been in a 3,000-square-foot, two-story adobe building. It includes a front room, camera room, prop room, downstairs dressing room and restroom, office/production room, pick-up area/concession stand, theater, upstairs office, upstairs gallery, full kitchen, frame room, restroom, and photographic lab. Previously I leased an 1,800-square-foot space where we had lots of exposure, both drive-by and foot traffic.

I work with my wife, Cheri, and my studio manager, Jennifer. Cheri is responsible for marketing and re-touching. She is also a freelance writer. Jennifer is my right hand for day-to-day studio operations, and both Cheri and Jennifer assist with sessions involving small children. I also have a husband-and-wife team, Kerry and Andrea, who color correct and print all of my work.

I shoot many sessions on location and market myself to keep it that way. It's not for convenience, because outdoor locations are at the whim of mother nature. Rather, it's because clients love locations because they are something different, and I love getting out to avoid becoming stagnant. The best way to promote creativity is to leave your comfort zone.

Do you have a philosophy that guides your approach to fine portraiture?

I don't think art should have to be explained. My philosophy about taking photographs is to make people look like they feel. I mean, most people prepare before they

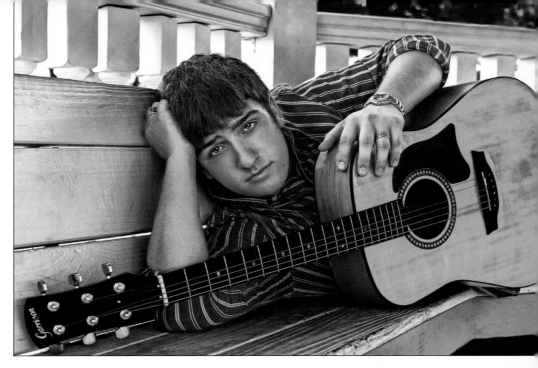

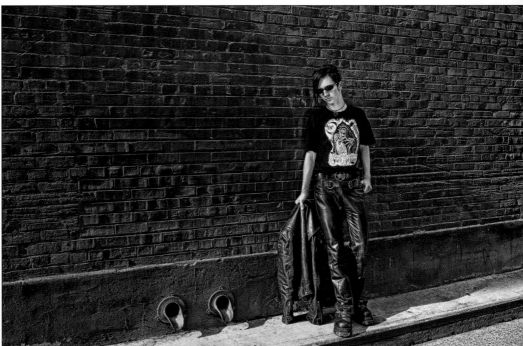

come for a session. Women shower, do their hair and makeup, and carefully select clothes. They wish to look their best, and my goal is to make what they see in their photographs match their mental image. I want a client to see photos and think, "My hips don't look as wide as I thought." Or, "I look pretty good, don't I?" I want them to look a little better than life. I'm not talking about changing someone's looks; I'm not into illusions. I believe a "portrait" can be real, honest, comfortable, and flattering. I think the greatest compliments I receive are

when people say my work looks natural, the colors look rich, and subjects look real.

I'm a believer in learning clients' names, whether it's a family of ten or a wedding party of twenty-five. I introduce myself immediately and learn everyone's name at the beginning of the session. I build my family sessions around the father as the nucleus of the group. It is a symbolic style I try to implement in each session.

Describe your approach to scheduling.

I don't employ staff photographers, because taking all the photographs means I maintain control over them with fewer headaches. Our studio is open for regular business hours Tuesday through Saturday, but out-of-town family groups, weddings, and outdoor sessions may be scheduled any day by appointment. I shoot all outdoor sessions late in the day for optimal lighting conditions, usually one, maybe two location jobs a day.

Owning the business allows us to schedule time out for ourselves or the family as needed. However, I try not to be "closed" to someone wanting a session. If a personal matter arises, I tell a client that I'm booked at that time. If I can't photograph a family session when they want it, I try to find another time, even on a day I'm not usually in the studio. But I only work seven days a week when circumstances make it necessary. Monday is a catch-up day, and I tend to edit some evenings at home, after my children are asleep.

Were your early business expectations realistic?

When I opened the storefront studio, I decided what I wanted to be when I "grew up." That required a plan for

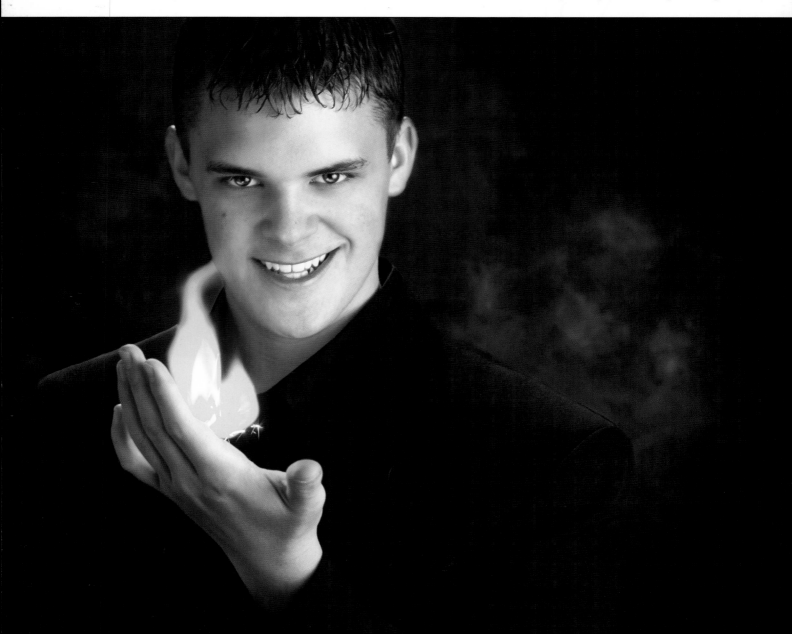

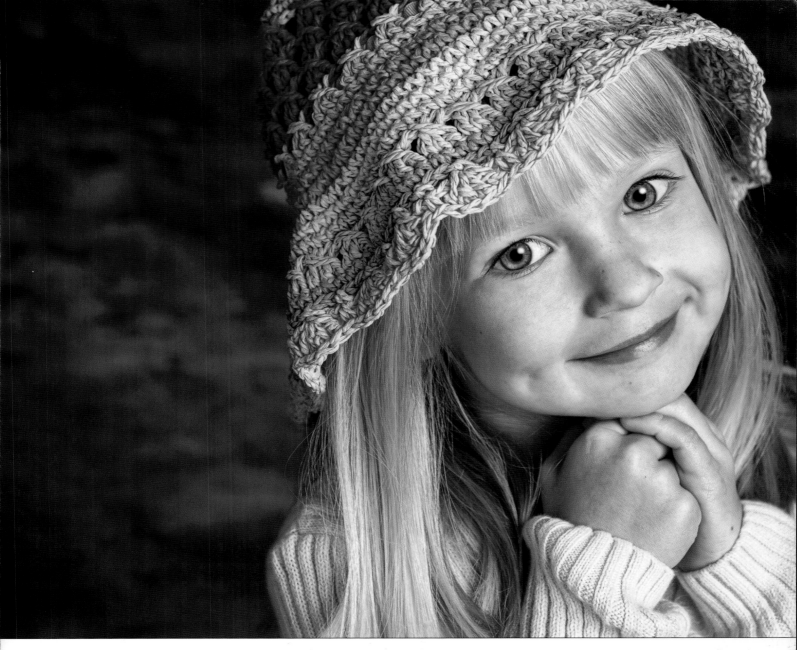

where I wanted to be ten, fifteen, or twenty years down the road. I knew I wanted to grow my business into an upscale, low volume studio, so I had to increase my customer base and my studio's name recognition. I knew I had to pay my dues.

How do you approach posing?

I try not to have any favorite poses, and I experiment all the time. I make sure when I try something new or off-the-wall I also shoot "safer" images for the client to choose from. You can tell which clients are up for something different, and which would rather be anywhere else than having their picture taken.

How does your communication with the subject play into the outcome of the portrait?

I talk all the time during a session because communication between the photographer and the subject is very important. During the setup phase, I talk about a client's interests such as family, career, or hobbies. My goal is to put a client at ease and make them willing to talk. Sometimes I ask for smiles, and sometimes I don't.

When photographing children as part of a family or individually, I always use an assistant who works directly with the children while I work with the adults. Our methods are amusing, and I find the adults laughing just as hard as the children. Afterward, I tell them we weren't trying to amuse just the kids. Sometimes, when the ses-

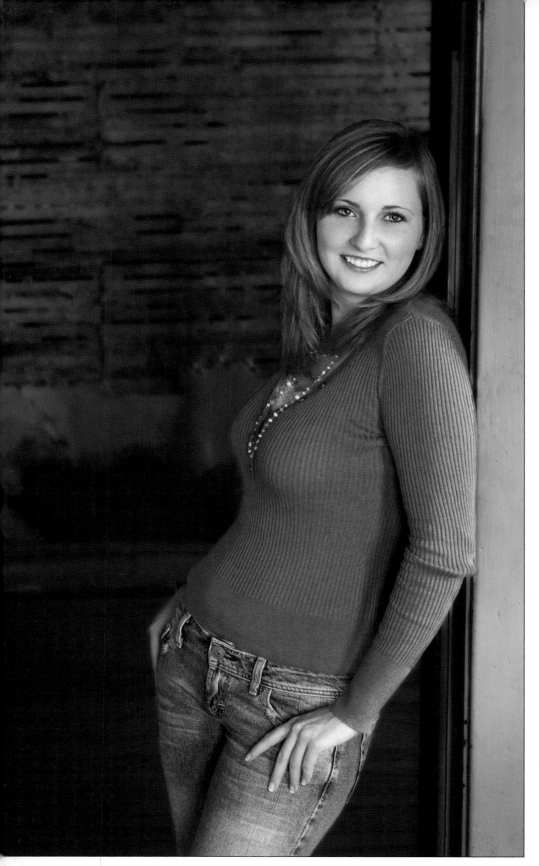

suggesting an activity that translates well into photographs.

What lighting equipment and approaches do you favor?

My studio lighting is very simple: a Larson Starfish is the main light, and I use a reflector, hair light, and sometimes a background light. Outdoors, I use the ambient light, usually a half hour before and up to fifteen minutes after sunset for the "sweet light." The sky is my reflector. I never use a strobe for outside portraiture because I don't like the look of artificial light in a natural setting. I occasionally use a reflector for individuals, but rarely for family groups. I shoot 50 percent of my sessions in outdoor light, which I find appropriate for most portrait sessions.

I also shoot in my loft in historic downtown Albuquerque, which has only window light, and I may use a reflector. The main window faces north, so I can shoot almost any time of the day. The loft, where I shoot mostly seniors, is in a worn down, century-old building. It's a no frills, no electricity, wonderful place with peeling wallpaper and paint, old wood floors, and original fixtures. Lately several movies have been shot there.

What type of backgrounds work best for you?

Permanently hung in my camera room is a 12x25-foot Old Masters canvas backdrop, rich with blues and browns. I also have about twenty-five different rotating muslin backdrops

sion calls for a more active portrait, a family will naturally fall into an activity like looking at flowers, skipping stones, etc. If necessary, I'll guide them in a direction by that I can hang in front of the canvas. They are not on pulleys because I want the flexibility of moving the muslin backdrop to various positions. I have a variety of props,

but I rarely use them. Like sets, they quickly become dated.

I prefer to have clients bring their own props such as a teddy bear or a blanket in a baby's photograph that gives their pictures meaning. I feel the same about popular factory-made sets. I'd rather take a client on an actual location where there are more potentially interesting backgrounds. The same props or sets used over and over can become monotonous.

Which cameras and lenses do you prefer?
I use the Canon EOS 1D Mark II and the Canon EOS 1Ds Mark II. The lenses I use most are 28–135mm and 24–70mm.

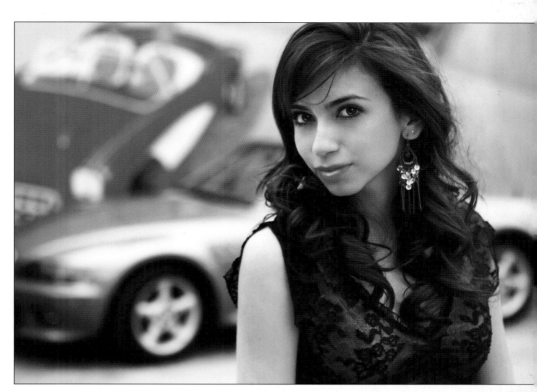

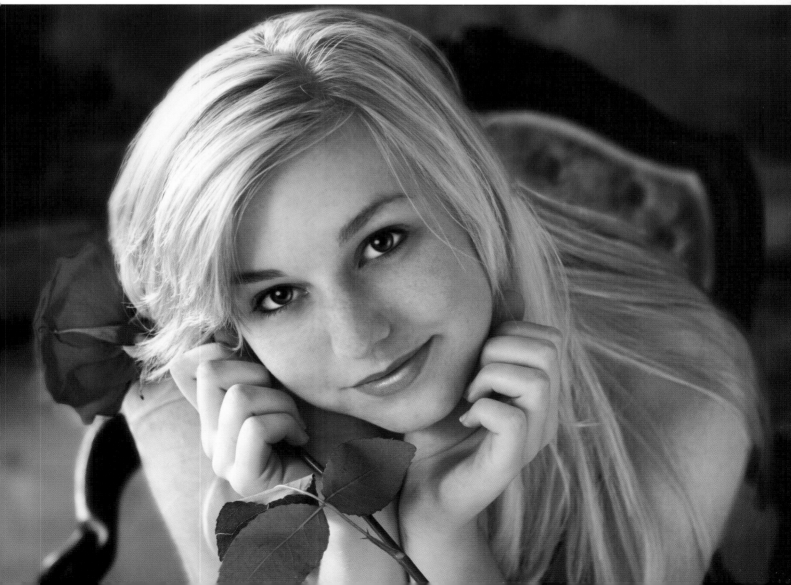

Do you create environmental portraits?

Not many of my location photographs are environmental portraits. However, I recently photographed a family that owns an ice skating rink, and we shot the first set at the rink and a second set with mountains as a backdrop. They picked a mountain shot for their wall portrait. Go figure.

Do you sell many black & white prints?

I find clients in their 30s or 40s ask for black & white because they consider it "retro." Seniors want black & white because it's cool. Clients in their 50s and up usually prefer color. They remember black & white, but it doesn't hold the same appeal for them.

Describe your workflow.

I edit my images. Cheri does those that require advanced enhancement, while Kerry and Andrea do minimal touch-ups. My lab is run by Kerry, because I believe a successful image is a team effort. It doesn't matter how great an image is in the camera, if it isn't enhanced or printed properly, it won't be successful. My lab provides control, and I know images will be rich and vibrant. I am also able to service rush orders and offer specialized services.

Using a Durst Epsilon LED printer as we do is not rocket science. But it takes talent and experience to see color properly and manipulate it with finesse. I feel we have to be careful in this industry because professional

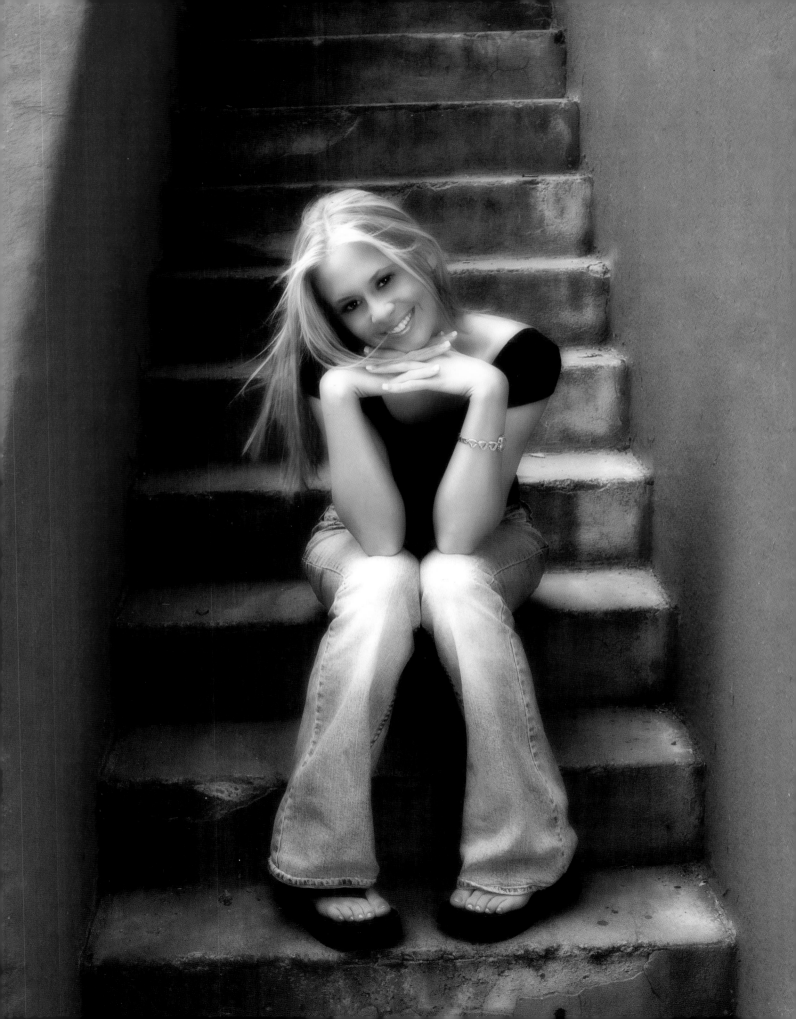

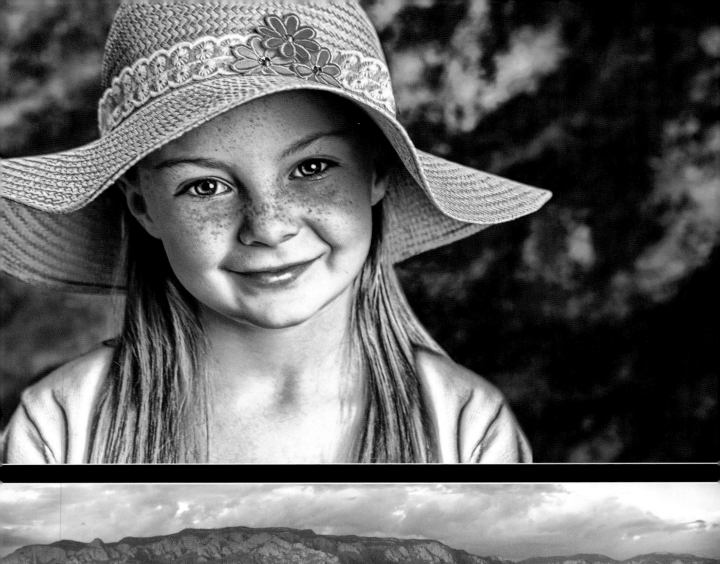

cameras are becoming more afford-able and clients are able to print their own images. We need to give them prints they can't get at home. I did not enjoy spending $100,000 on a printer, but it was a worthwhile in-vestment that allows us to produce digital images on photographic paper with colors so rich they pop off the page.

How are your clients' images presented?

Clients used to take their paper proofs home for a while, then place an order for one 8x10 and four wal-lets. They had looked the pictures over so often that their appetite for them was satisfied. I abandoned paper proofs at least fifteen years ago. I used the Kodak prism system to show images on a large screen in the studio, and projected slides for loca-tion sessions. Now I project each ses-sion in the studio's theater, complete with popcorn, candy, and iced Coke. I work with clients personally during sales appointments since we have al-ready established a relationship. I am not considered a "salesperson"; I'm the photographer, the "expert" stu-dio owner who came from behind the camera to give them the atten-tion they enjoy and appreciate.

How do you structure your pricing?

I'm not certain if we are medium-high or high priced. It's all subjec-tive. I consider myself medium-high, one of the more expensive in town. I charge a minimum. Every client who books an appointment prepays a re-tainer. I don't offer packages because I feel they tell a client what to buy. I would rather a client leave the studio

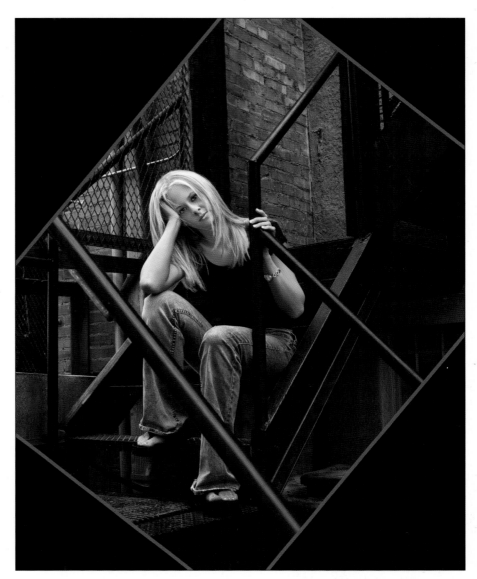

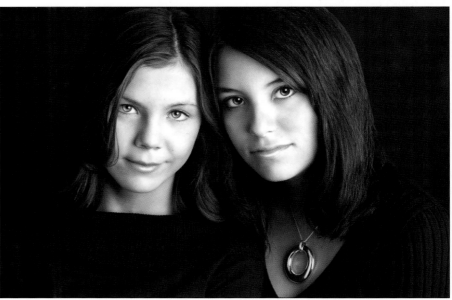

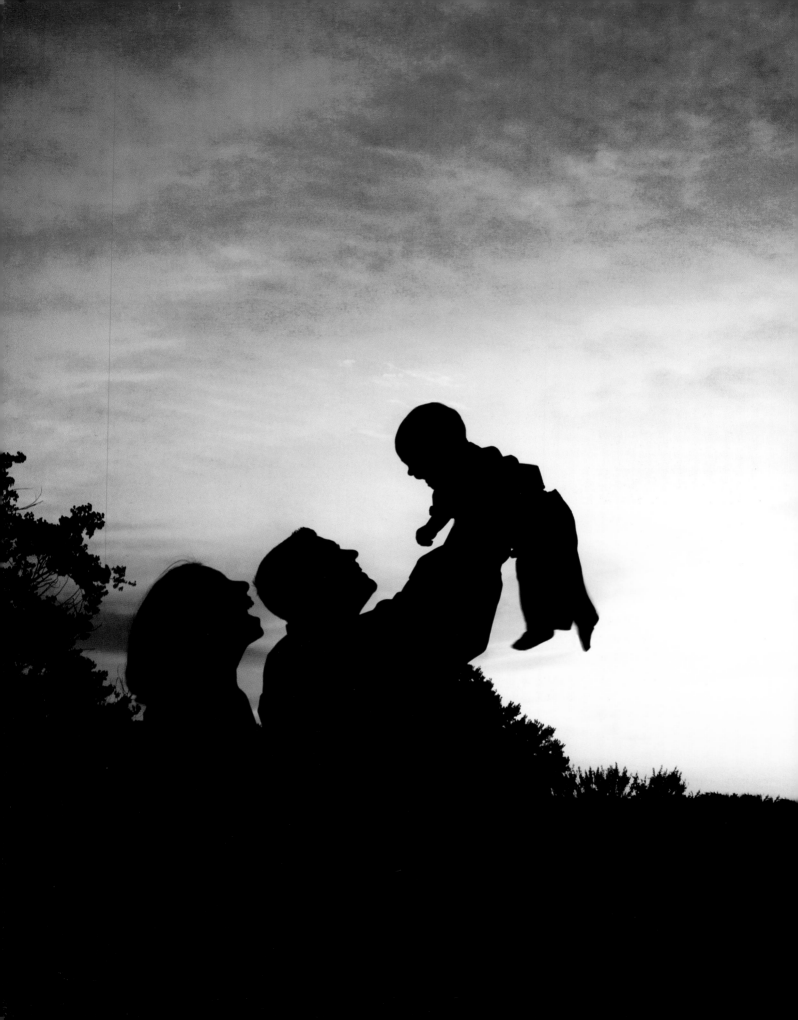

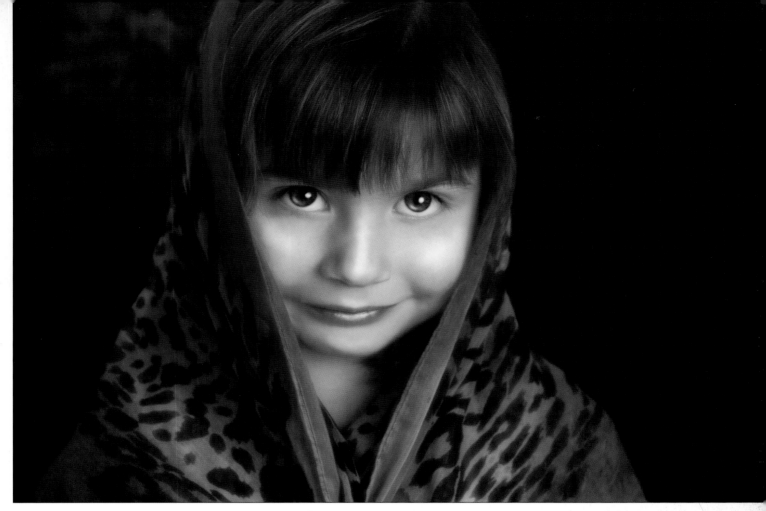

with one picture less than they need than with a box full of surplus photos. I like them to leave wanting more.

I don't squeeze clients to buy. I want to establish a long-term relationship with them, and chances are if you pressure clients, you won't see them again. I gain more revenue from a ten-year relationship than by pushing to sell two extra 8x10s. Treasure your loyal clients and they'll drum up business for you.

How do you promote your studio?
I promote the studio via television and direct mail. All of my advertising is geared toward building the studio image. My wife writes and produces all of my spots and creates our printed pieces. We don't try to bait readers or TV viewers. I strongly believe it

costs less to keep your existing clients than to acquire new ones.

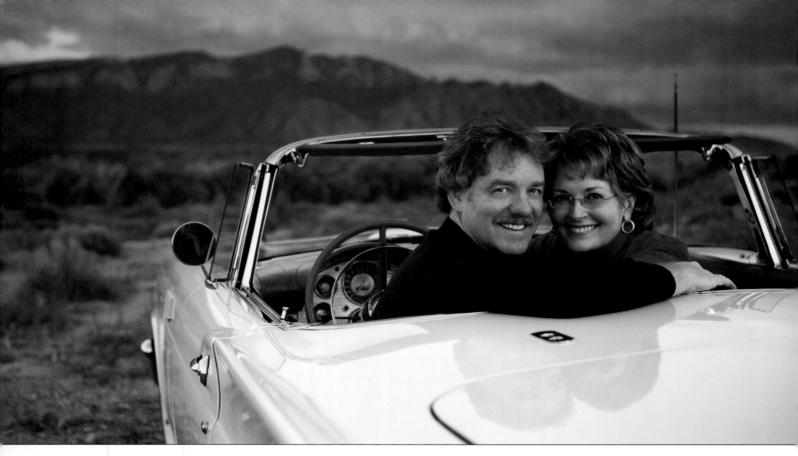

I do photography for Comcast, and they provide me with wonderful trade-outs, which I use during key times of the year. I also rent a kiosk in a mall to display images and promotional take-home materials. I market heavily to seniors, spring through fall, with multipiece campaigns. I provide gift certificates, which are auctioned at charitable events. Certificates are for a set dollar amount, to be applied as the recipient sees fit rather than for a set portrait size. When a client comes into the studio with a $200.00 certificate, the amount is considered a credit to be used however they wish, and many people use it to order a variety of sizes. If you give a free print, you're telling people what to choose, making it less likely they'll order more. At each auction I also display a wall portrait alongside the certificate. With a large number of people attending these functions, it's a good bet your work will get noticed.

Are there any business details you'd like to share?
When I purchased the mom-and-pop studio I had savings to get by on for two years, and everything I made went back into the business. The studio had a good reputation, and I wanted preexisting clients. Though I paid a lot for that little studio, in retrospect I don't know if it's better to do what I did and work hard to keep it, or start completely from the ground up. It's such a personal decision.

With our business plan, I do pay myself a salary as a normal expense.

How important is a photographer's personality to his or her success?
Personality is everything! You can be an average photographer with a great personality and a great business sense and do exceptionally well. On the flip side, you can be a great photographer with an average personality and average business sense and find yourself applying for food stamps. Personality and a head for business are a terrific combination. Success also has to do with finding your niche—one that makes you stand out from the crowd.

5. SUZANNE MAITLAND

In late 2001, Suzanne Maitland was living happily in Marietta, GA, as a wife and mom. She felt that the pictures she took of her sons were above average, and discovering www.zuga.net helped raise her photography to a higher level. She enrolled in a class with Monte Zucker, who inspired her, and she learned her craft. Now she photographs families and children, does all her own computer enhancement, and gets a thrill "documenting multiple generations." To learn more, visit www.suzanneportraits.com.

Describe your background.

I've heard it said, "The meaning of life is to find your gift; the purpose of life is to give it away." This quote resonates with me because I was forty-four years old before I discovered my gift—the ability to connect with people through photography. It was an amazing feeling to finally know what I was meant to do. Fortunately, I have been able to create a business based on this gift and also use it to help others.

With a BA in journalism, I worked in sales, copywriting, and office management. I wasn't a photography devotee, but I had always been intrigued by people and art, and I knew I wanted to have my own business someday. This drove me to earn a masters degree in business (MBA) from Johns Hopkins University where I graduated with honors in 1990.

Soon after, we started our family, and I continued to ponder where my life would lead me. It wasn't until I chanced upon a photography forum in 2002 and was encouraged to study with Monte Zucker that I realized where my entrepreneurial efforts would be directed. Fueled by passion and balanced by maturity and knowledge, I set out to start a business photographing people.

Who are your influences and mentors?

I continued to study in-depth with Monte, who was a fabulous mentor. I requested hard critiques, and he gave them to me. I used his advice to improve my photography. He admired my diligence and ability to take it straight. Additionally, he encouraged me to seek out charitable work for both professional exposure and personal satisfaction. Much of my growth as a photographer has come as a result of giving away my gift.

I've also been influenced by Tim Kelly, Joyce Tennyson, Marc Hauser, and others. I look at imagery everywhere for inspiration. I am active in Wedding and Portrait Photographers International (WPPI), which I highly recommend.

How has your career evolved?

I specialized in portraiture from the beginning, and gained confidence as sessions and sales increased. A solid track record of well-crafted images made me comfortable presenting my artistic compositions. The clients I attract want something different, and I educate them about composition and the opportunities artists have to provide prints of all shapes and sizes. I visualize and compose in-camera without worrying about making an image "fit" in an 8x10-inch frame.

Describe your studio.

In April 2006, I moved to a residential studio that sits on two-plus acres. While I still encourage (and greatly enjoy) sessions at other locations, I am now able to offer outdoor portraits on my studio grounds. I also added a camera room and began using continuous lights (hot lights)

because they mimic the window light I use in natural settings. I use Westcott Spiderlite TD5s and have one large and two medium-size units.

My business is about 80 percent babies, children, and teens; 10 percent families; and 10 percent adults. Often I suggest a home environment for younger children. Multigenerational sessions are most conveniently done at the client's home. If the client has a lovely yard, I stress the extra level of value this will add to their portraits. I include an assistant at most sessions, except for adult headshots when I want the least pressure on the client and we can form a connection/collaboration more easily while alone.

How do you approach your sessions?

My goal is to stay in tune with the person in front of my lens. I talk constantly, watch for signs of tension, and offer tips to achieve relaxed faces and bodies. My level of concern and attention to detail leads the subject to feel he/she is working with a professional who cares. Enthusiasm and excitement help tremendously too. I always express delight when I like what I'm seeing. When I show

clients their images on the camera's LCD, our collaboration intensifies.

Do you have a philosophy that guides your approach to fine portraiture?

To me fine portraiture is simple, elegant, and real. It stands the test of time.

I believe photographers have their own unique style because of who they are. They inject part of themselves into the image. The way the photographer interacts with the subject makes a moment come into being. Each captured moment exists because you made the choice to click the shutter. The final, postproduction image bears the artist's signature as well.

Describe your approach to scheduling.

We do not schedule appointments for Mondays, which is when we prepare for the week ahead. Sessions, consultations, presentations, and pickups take place Tuesday through Friday. I schedule two sessions per week, except for peak times when I do three sessions. Work with children is always scheduled to meet the youngest subject's scheduling needs.

I accept a maximum of two weekend sessions per month—and these are offered at a premium, so only those who absolutely need a weekend will book. A majority of clients would choose a weekend slot priced the same as a weekday.

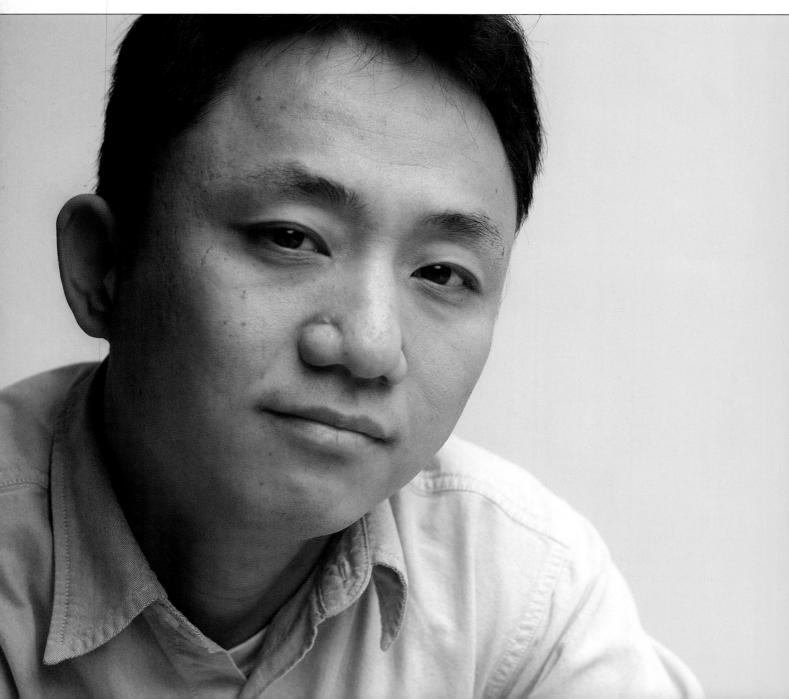

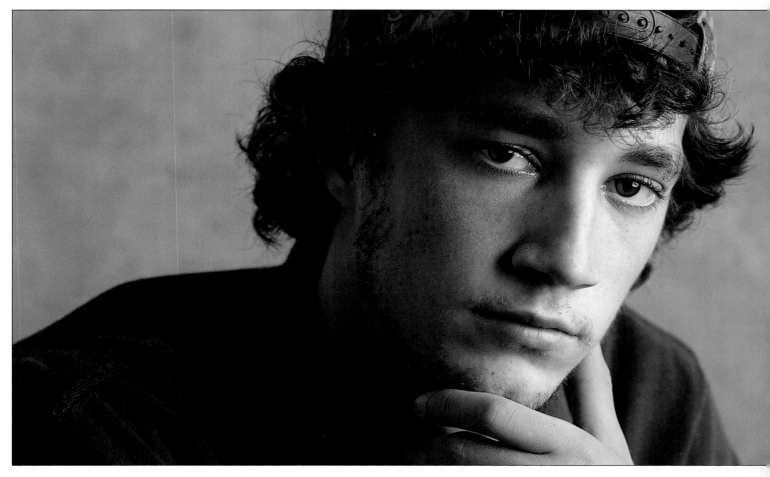

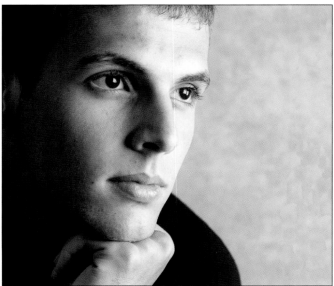

Were your early business expectations realistic?
With an MBA and experience working for entrepreneurs, I had a realistic understanding of the struggles and time frames for start-up success. I made sure I had an accountant before I started taking clients.

Most important was my choice to be a low-volume, high-end studio. From day one, I prepared everything from prices to my web site and promotional materials accordingly. For instance, I set my creation fee high to signal "high-end." That limited callers. I wanted to grow slowly and take time refining my business. I wanted clients to appreciate the value of what I was creating for them. In the first year I fine-tuned every aspect of my business. I analyzed interactions with clients and realized

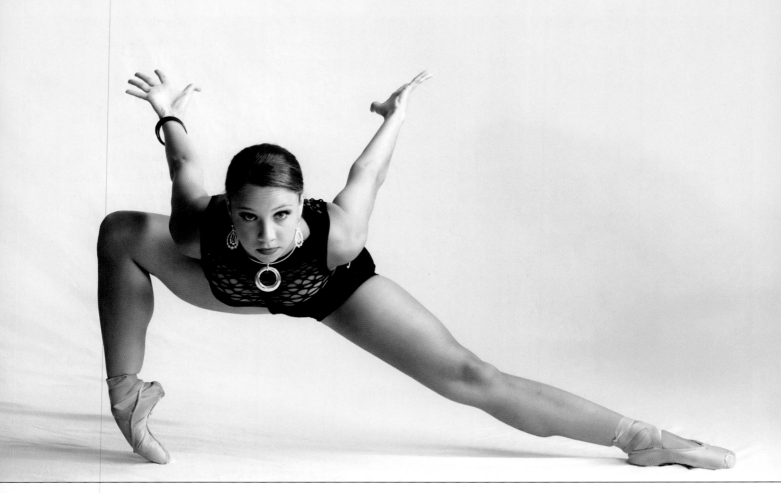

that many problems were due to a lack of communication. I made improvements. For example, people didn't understand that my coffee-table books are priced on the number of images used, not on a set fee. I needed to clearly explain that each image has the same value, whether in the book or as an individual print.

In 2003, I contacted a dance theater about a display opportunity. That grew into a huge marketing/advertising opportunity. That year I also established a coffeehouse exhibit, which I still maintain.

My career progress was both emotional and technical. I learned a lot about people and selling, as well as equipment, Photoshop, posing, and lighting. I improved my workflow process. Much knowledge was gained from fellow photographers on online forums and at conventions and workshops.

How do you approach posing?
Because of my training in classical portraiture, a lot of what I do with each subject is instinctive. I "read" them and start where they are and work to flatter them photographically. I pose for a natural look and want them to love what I capture, their real essence.

How does your communication with the subject play into the outcome of the portrait?
I feel most subjects need to be engaged, made to feel fully a part of the process. I took a few entry-level college psychology courses, but I've gained more understanding through life experiences. Yoga has been instrumental in helping me see tension in the body.

I don't ask for smiles from children under eight, but I do from older kids and adults. I ask for a smile in the eyes, or say, "Let's see your teeth." I will often simulate the pose and explain how I am positioning myself. As for gestures, I act out how to place a hand or bend a leg.

When a subject is shy, I try to get to know their interests and talk and laugh. I say how hard it is to be on their side of the camera. I lighten the mood with oohs and aahs. I love the ability with digital to show images

to clients, especially for shy people. It helps build their confidence.

I shoot sequences when I sense a series of poses will naturally arise. As I click off frames, people usually relax.

What type of backgrounds work best for you?

In the studio, I hang backgrounds from stands. I also have a free-standing corner unit that is hinged together so I can vary the angle of the corner. I am a minimalist when it comes to sets. I have a collection of chairs and benches and an antique tea cart I love to use. For props indoors, I use only personal items brought in by the client. Outdoors I may use a cut flower, a stick for a young boy, pebbles, or leaves. Less is more.

Do you conduct any location sessions?

Outdoors I enjoy the variety and the challenge of finding the right light. Overhead cover is a must. Sometimes it's a porch, awning, part of a building, or shade from a tree, an umbrella, or a scrim. I control natural light with reflectors and/or gobos. The decision to shoot outdoors is based on the style or mood the client wants after review-

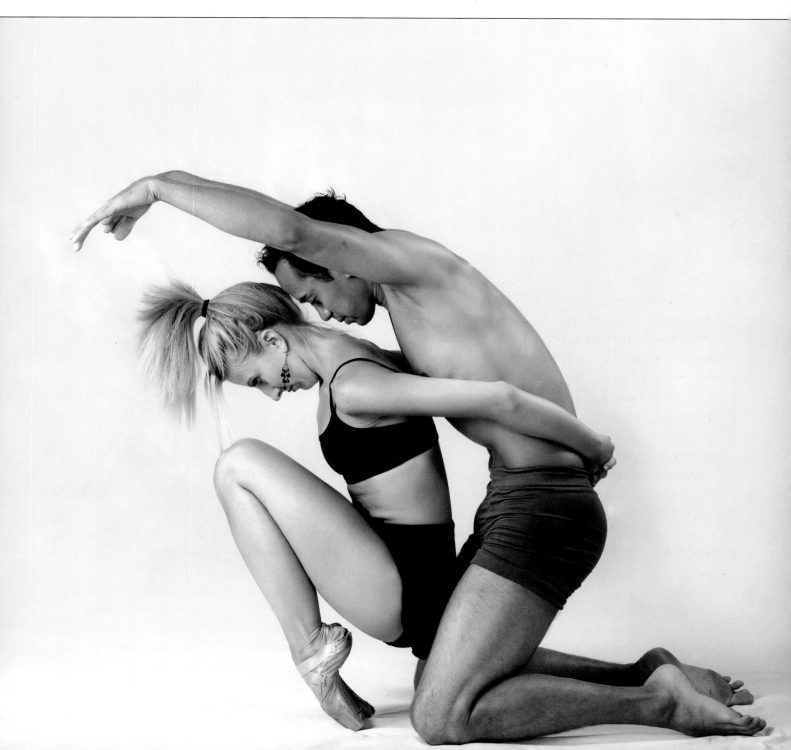

ing my work. For low-light situations in homes my West-cott Spiderlites are very handy.

For senior pictures, the teen's own room or a special space adds tremendously to the photographs. Places that tell the viewer something about the person are satisfying. Grungy urban alleys and anything edgy or nontraditional can also be great.

Do you create environmental portraits?

Toddlers, in particular, benefit from being in their own space. That comfort and security help young subjects relax. My coffee-table books are more meaningful when the child is photographed at home where many memories are included.

For professional subjects environmental images are often a perfect choice. Showing someone in their work or home environment adds another level of value to the image.

Which cameras and lenses do you prefer?

I use the Canon EOS 1D Mark II. The Canon 50mm f/1.4 lens is a favorite because it's fast and I like to shoot at wide apertures. With young children and babies I can get close to keep their attention. The Canon 70mm–200mm f/2.8 IS lens is great for super-tight headshots. It also works well for dance photography in low light. The Canon 28–135mm f/3.5–5.6 is ideal for group portraits.

Do you sell many black & white prints?

Some clients ask specifically for black & white, and I explain the styles of my work that adapt best: generally relationship images and those with a storytelling feel.

Describe your workflow.

I do all my own editing. Soft, flattering, believable retouching and art-working such as cloning, enhancing, and vignetting all play a part in creating the look I want. I am very detail-oriented, and minor things that could catch the viewer's eye—something as small as a white button on a dark shirt—may be toned darker to avoid being a distraction from someone's face. Also, when I am editing I see new things such as cropping variations.

While I want control over the look of the image, I outsource printing to experts. Miller's Professional Imaging

makes all my photographic prints. Digital Arts Studio in Atlanta does my fine art prints (giclées on fine art paper or canvas).

How do you structure your pricing?

I have always had a "first price point" for my images. Labeled "small prints," they can be any size the client desires up to 8x10 inches. Wall portraits are a separate category and are available in three finishes: standard photographic prints, fine art paper prints, and canvas prints. Each is more expensive than the previous type. I sell only à la carte, no packages. I am in a medium-to-high price group in this area.

I sell custom sizes and educate clients to view my images as art. Some compositions are not typical shapes, which makes my portraits stand out from the ordinary. These nontraditional formats work since most clients have their prints custom framed. When a mat is used, the opening is simply cut to the print dimensions. I generally sell at least one or two prints in the 18-inch range. Larger wall portraits are done on fine art paper or canvas and generally sell at the 30-inch print size. I tell my clients that we don't have to be locked into pre-set shapes. I want them coming to me because I offer something different. I also offer coffee-table books and design them myself using Asuka Book (www.asukabook.com) exclusively.

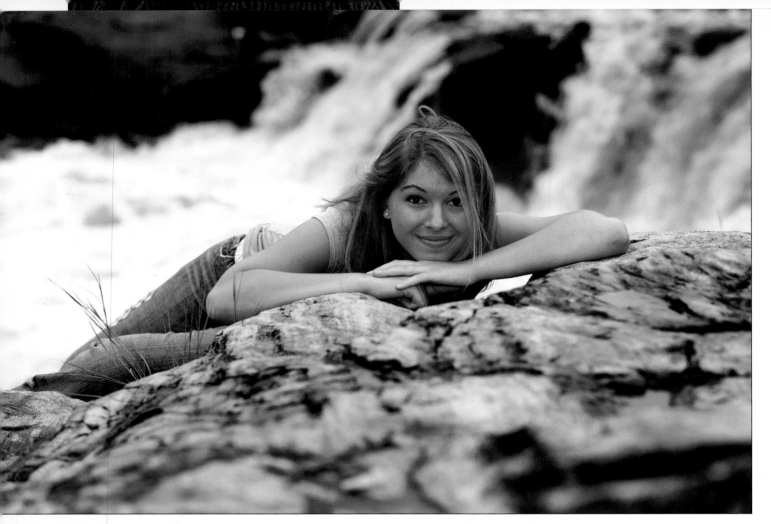

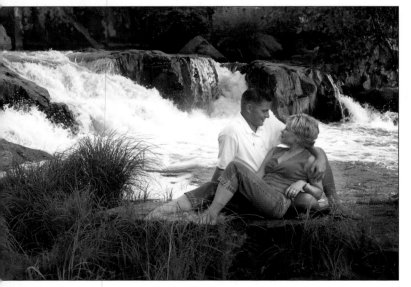

what they were doing and adopted some of their techniques so my work would look different from most other photographers' portraits.

Don Blair and Michele Gauger influenced the foundations of my photographic style. Robert Lino and the late Dean Collins influenced my glamour style. While glamour photography comprises only about 20 percent of my studio's business, that style influences much of my work. All my high school senior girls want to look like models, and seniors are 60 percent of my business.

Describe your studio.

I worked out of my home studio during a three-year transition from photojournalism to portraiture. I continued to take assignments with the local newspaper and shot for Chippewa Valley Technical College, creating images of students for the school's cutting-edge programs.

In 1994, I moved into my current building, an 1880s bank on the main street of Fall Creek, WI (population 1,250). After renting half the building, I bought the property in 1998 and began restoration. In 2004, I

Who are your influences and mentors?
When I caught Monte Zucker's 1999 tour, and that of portrait artist Al Gilbert, I was blown away by their use of barebulb flash, as opposed to using softboxes, umbrellas, and reflectors. Those photographers had fluid posing styles that made subjects look really natural. I analyzed

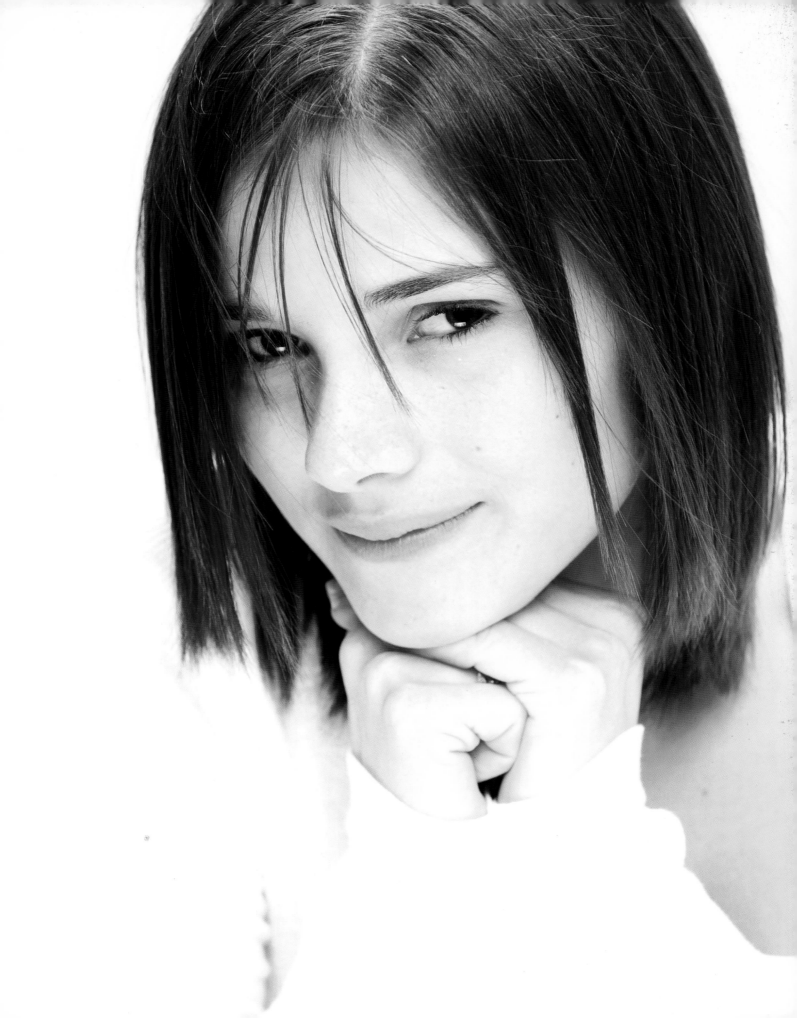

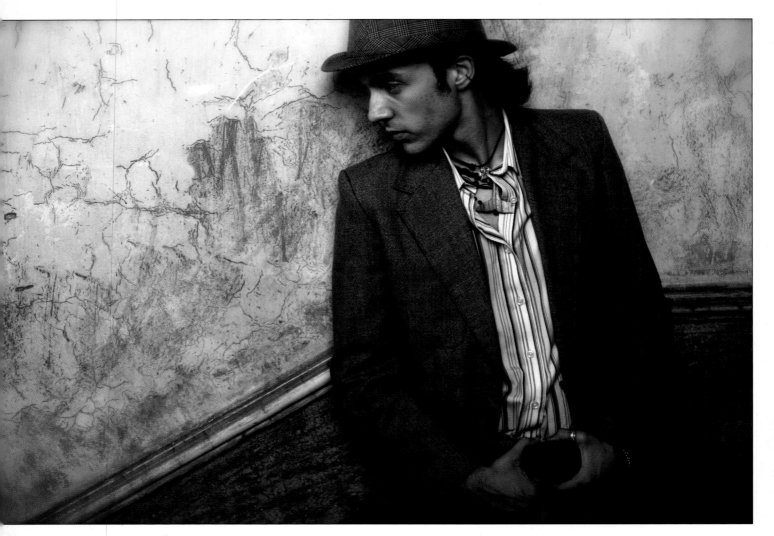

added a large window-lighted camera room, a new production room, and a second dressing room. The studio is now about 3,000 square feet. Though I have two camera rooms, I still do a lot of location work because my clients and I love the variety. Many photographers in the vicinity don't leave their studios.

I have three employees, my daughter Erin, my son Tim, and Ashley who does a little of everything, except shooting. She specializes in Photoshop, retouching, and finishing images, does client consultations, and a good share of the sales work.

Erin is like Ashley's understudy, with much the same aptitude for graphics software applications. She has a great eye for design and is in training for high school senior album layout. Tim is a high school junior who enjoys being second camera at weddings, doing mostly candids. We expect when he's in college he can shoot weddings on his own.

How do you approach your sessions?

The root of portraiture is the word *portray*. Photographers seek to visually portray their clients in artistic images that describe aspects of their lives or personalities. Before sessions I normally do a consultation where we get to know each other and exchange ideas; that helps keep us on track. How I approach getting what they want evolves through my style, coming from my consciousness and vision. If a casual observer can identify with and understand the meanings conveyed by an image, it's a good, if not a fine, portrait.

Describe your approach to scheduling.

We're constantly trying to bring order to scheduling because demand is high and I'm the only shooter. I reserve Sundays to catch my breath and spend time with my family. During April to October, Saturdays are wedding days. A third of my time is devoted to studio work, and the

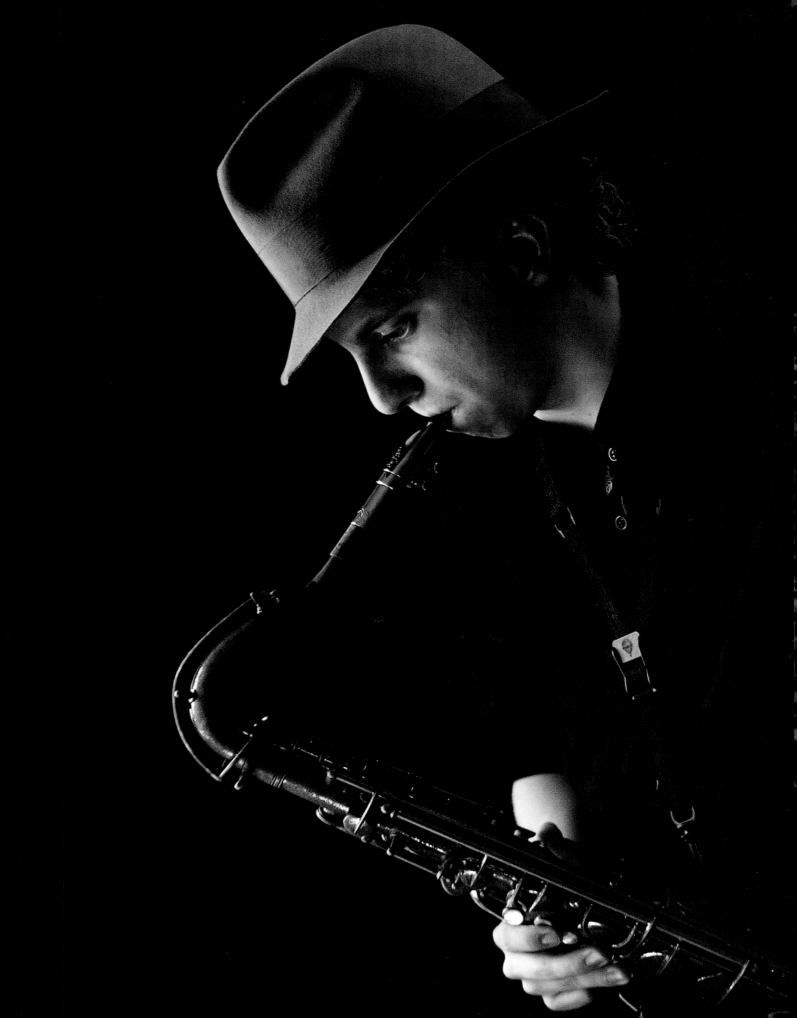

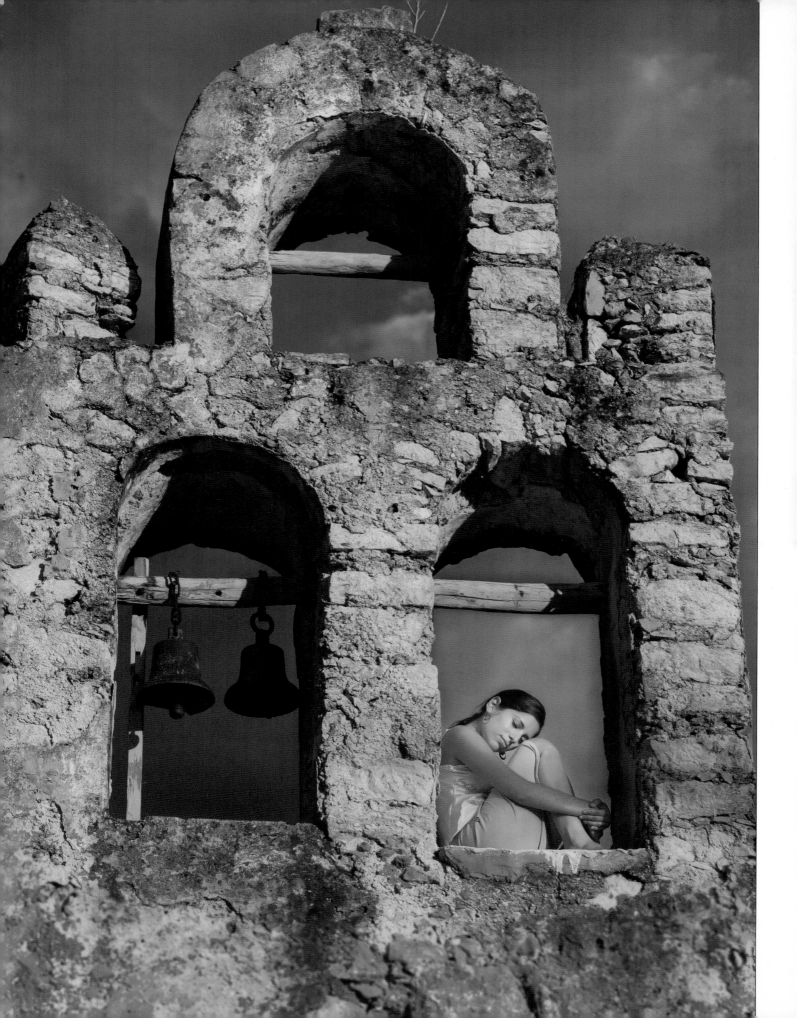

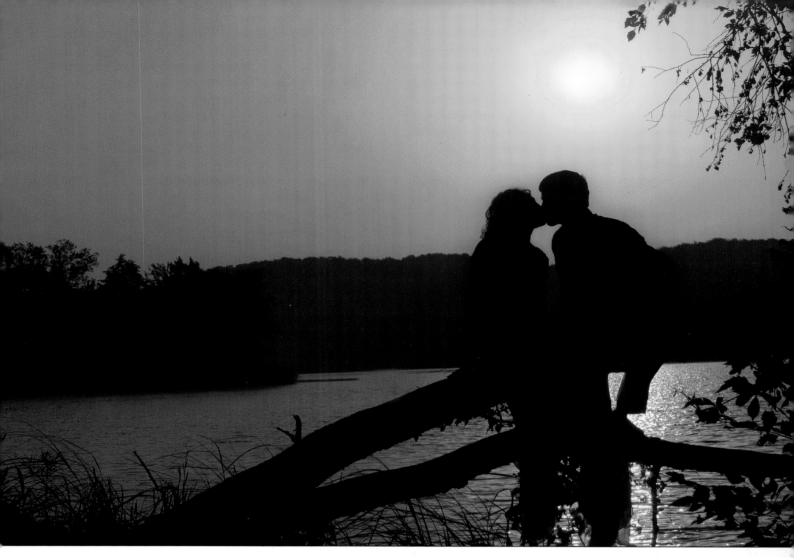

final third is time off during which I may teach, attend workshops, handle speaking engagements, and attend trade shows January through March. I create all our yearly advertising campaigns and tweak our marketing calendar in winter.

Were your early business expectations realistic?
Not at all. I thought I'd have success within five years, and it took ten. Early on I took an entrepreneurship class at the local technical college and learned how to control costs and manage cash flow. I also learned sound marketing and pricing methods. Newspaper assignments helped me maintain a meager but regular cash flow.

In January 1997, I almost decided to give it up, but didn't because I lacked enough money to return twenty or so wedding down payments. I decided I was going to be different and build a fresh professional image. I began a six-year relationship with Sondra Ayers and Jerry Deck of Power Consulting to help me build that image. I learned I couldn't market a product that didn't have a look that expressed my style. I studied and attended workshops to hone my photography skills.

How do you approach posing?
I have favorite poses, but they have to fit the subject. A pose might look great for one person and awkward for another, so you have to analyze your subject. My job is to accentuate the good features and downplay or hide what we don't want to show through lighting. I try to make a positive aspect of the subject's appearance so dramatic and compelling that viewers don't notice a negative. For example, I created a glamour portrait of a woman who had recently had a baby and hadn't lost all of her belly. She said her husband loved her butt, so I posed her with it at about a 30-degree angle to the camera and had her twist at the waist and look over her shoulder. This hid her tummy, and we chose a high key background with a hint of pink, which blended with her outfit.

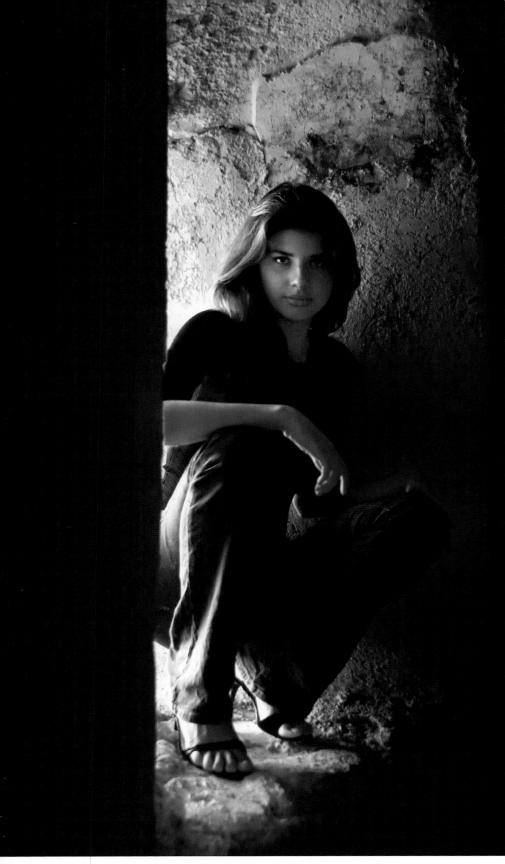

they do something that looks good, I tell them and then light that pose so it looks natural. This saves the effort of trying to fit someone into a pose. For example, I told a senior girl to pose on a stool in front of a formal background. Instead, she knelt on it, sitting on her hocks, a pose I've never seen before. I said she looked great. I turned the stool about 45 degrees away from the main light, and she turned to look at me. The picture was uniquely her.

What strategies do you employ to communicate with your subjects and elicit the desired expressions?

I often describe the photo session as a stage performance where the part clients play is to talk about themselves. I reassure them, especially shy clients, that it's my job to make them look good. "What's the most important thing about a picture?" I'll ask, and I get all kinds of answers. I'll say, "The real answer is that you look great. The better I understand what you want, the better I can do this."

In my orientation about posing, especially for women, I mention the ability to move body parts separately, face toward the light, and tip their head over their left shoulder. I'll tell them, "Don't move your upper body, but turn your hips away from me to the right." I also tell people I don't want them to smile all the time, that we need to capture a range of moods and expressions. I'll suggest, "Point your chin toward me a little," often getting a slightly bewildered look. Their cooperation shows they know I care what their images look like.

In the last few years, I've adopted a new posing style by letting people pose themselves. I have clients talk about themselves and I watch their body language. When they know I care what their images look like.

Shooting sequences is critical. If you get a good pose, quickly get different angles that really add variety to a sit-

ting. Ask clients not to abandon a pose as soon as they hear the shutter click.

What lighting equipment and approaches do you favor?
Dean Collins used to say, "People like their faces looking thin." For this I prefer a short light, meaning the subject's shadow side is toward the camera. For men, I frequently use a basic pattern, with body and face toward the main light. For women, I'll use a feminine pattern, with the light crossing her body and her face turned back to the camera. This is forgiving and slimming and is generally a good place to start while deciding which rules can be broken.

There's no single type of mood lighting, but for lighting to be dramatic, it needs to be directional. For faces, a loop pattern with the short side toward the camera is my favorite, depending on the mood and attitude. For young beautiful faces, a butterfly pattern is great, angled a little to one side.

A Rembrandt pattern works well for round faces, and when you want a softer look like in an engagement portrait. If you bump up your highlight-to-shadow ratio, you can get a very contrasty, edgy look with a different message. Nothing is edgier than a split light, which I often use on high-contrast black & white work with seniors and with sports images for an intense look.

In the studio I use everything from 4x6-foot softboxes, to honeycombs, to little video lights, to 1940s gooseneck lamps, to window light. I have one camera for strobe and artificial light and another I use to photograph by a 30-foot expanse of 6-foot high windows facing north and west. I like afternoon light used as a main or a separation light.

I often use modeling lights as hot lights, and I may use strobe to light a face with tungsten on the background. I call some of my hot lighting Coppertones, in which we only partially correct the tungsten. It's great for Wisconsin complexions in winter. I also like using strip boxes for narrow directional light. Honeycomb grids do much the same, creating a narrow round beam. The more varied types of lighting I can use, the more creative I can be.

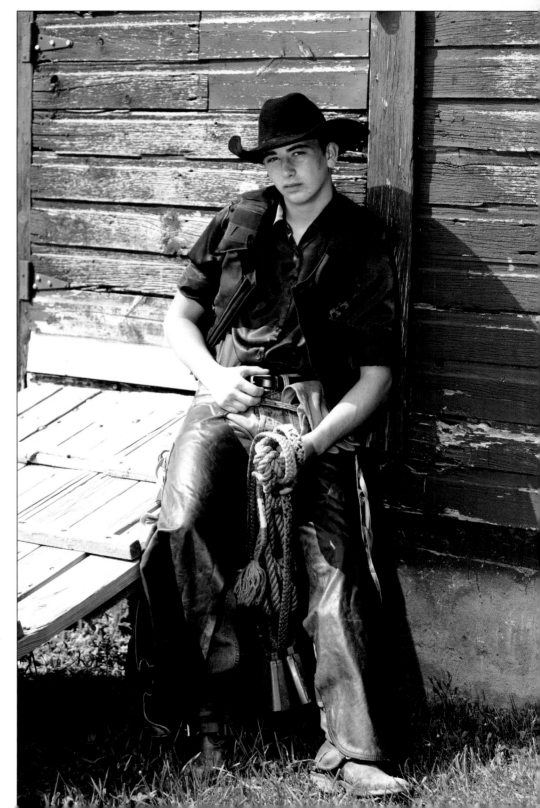

What type of backgrounds work best for you?

When we expanded the building we left the exterior brick exposed. I add props such as an old antique radio and phonograph, or antique furniture. I prefer props you find by chance to those from photographic catalogs, though I do have some of those. I also own painted backdrops, both muslins and canvases.

When a contractor remodeled a house near my studio I was given great old columns, a couple of which now frame the Plexiglas block window I built. I covered the cracked paint of the columns with a light coat of turquoise paint that harmonizes with the earth tones. The columns are used as the center of a set with the Plexiglas window backlit using a tungsten lamp.

Do you conduct any location sessions?

At least 60 percent of my sessions include an outdoor segment, which pleases seniors, couples, and families. We use one of our terrific locations like the rusty riveted steel and geometric trusses of an old railroad bridge. I work in nat-ural light at a dozen or so spots near my studio, and I often augment with a strobe. The sun is a main light, the ambient light level is another, and my strobe or reflector is a third.

Where the sun is intense and there's no shade or re-flected light, I'll use the sun as backlight with a portable strobe as a main light. If the ambient light level is f/5.6 at 1/250, I'll set the strobe at f/5.6, which gives me an f/8 highlight or a 2:1 ratio. An f/11 separation light (the sun) gives the subject's hair a beautiful highlight.

The junkyard is another favorite spot for seniors. I found it doing a senior session for the owner's son, and I immediately made arrangements to shoot there often. I also use a rustic barn with peeling paint, a hayloft, and antique implements. Horses, goats, geese, turkeys, and ducks add to the atmosphere.

Which cameras and lenses do you prefer?

My favorite camera is a Canon EOS 1D, the original 11.1-megapixel version. It has hundreds of thousands of

exposures on it. My backup is a Canon EOS 5D, which is also great, but though it's newer it doesn't produce the quality of skin tones the 1Ds does. Both use a full-frame sensor (36x24mm) that takes full advantage of my Canon lenses, a 24–70mm f/2.8 and a 70–200mm f/2.8 IS. I also carry a Tamron 17–35mm f/3.5–4.5, and for ultra-wide-angle shots I have a 15mm fisheye.

Do you sell many black & white prints?
My studio is known for images with deep blacks and brilliant whites, and not a lot of gray in between. I use an older Fuji S1 for black & white because, exposed properly, files are useable with little tweaking. We do black & white because clients of all ages love it, and without color as a distraction, it forces viewers to concentrate on your subject.

Describe your workflow.
All our portraits are finished digitally. The heavy lifting gets done in Photoshop, but I also use iPhoto and Apple Aperture to prepare images for polishing in Photoshop. Finished images in folders are transmitted via the Internet to our lab, WHCC, which prints them as we've prepared them. We require the help of a full-time employee to get this done, but it's a good trade-off because we can do finishing and design that was impossible just a few years ago.

About 75 percent of our output is still on silver halide professional papers, but that is changing. Probably 40 percent of our session books are printed digital offset. We also do metallic papers and high-quality inkjet on fine art watercolor-type papers, popular for wall portraits. We are getting away from standard size prints in favor of sizes that fit the composition of the picture.

How are your clients' images presented?
Since I have been projecting and showing slide shows my sales have steadily increased. However, the fact that I am marketing my studio as the area's cutting-edge one, and have worked to improve my skills, are also factors in the increased sales.

Most clients get the option of viewing a slide show (we call them screenings) of their sessions before they leave the studio. Using iPhoto we can create slide shows featuring sixty images in about ten minutes, set it to music, and show it to our clients. Instant gratification is impressive, and 95 percent of clients buy session books immediately. The images are prepared for Photoshop and exported into a finishing folder immediately, so our ten minutes' work is really valuable.

How do you structure your pricing?
We probably rank third highest of the top ten more expensive studios in our area, because we have built the rep-

utation as the most creative studio. We give clients a great value. I raise prices pretty much every year in small increments. Also, I'm always coming out with new techniques, processes, and products, so the client's perceived value is always growing.

Recently the two best selling print sizes for families are 16x24 and 12x24. These more panoramic sizes fit environmental portraits better and encourages people to purchase the frames we have custom made for them. In exchange I keep my markup rather low on frames. It's worth it to see a really nice looking framed portrait go out the door.

How do you promote your studio?
One main advertising site is a mall kiosk where we have a 10x18-foot display at a key spot; it's expensive but worth it. We rotate images often, and clients who appear in the display are flattered. Once a year, we sell the prints at 55 to 70 percent off list. Equally important is our web site, which keeps growing and is really quite a bargain. Do your best to keep your web site fresh. The more places you can reinforce your message, the better.

You are in a position where your photography can promote a lot of other businesses (or nonprofits) and end up photographing in the process of doing your job. This type of networking is huge and often doesn't cost much. I make images available to hotels, limo companies, bars, hair salons, radio stations, and hospitals for nothing more than a photo credit. It's surprising how much word of mouth you get as a result.

We also do as many as twenty different mailers a year, many of them smaller like our re-order and customer appreciation sale, plus the four we do yearly to our senior prospects. Always refer prospective clients to your web site, where you can put more detailed information. I also do radio advertising and trades for promotional events as well as giving sessions away to nonprofits and community organizations.

How important is a photographer's personality to his or her success?
Your personality and your ability to communicate with and understand your clients is critical. They will love you for making the effort. In addition, you need to decide what kind of image you want people to have of your studio. They need to understand what kind of photography you do. Image and branding is important, and you have to make the decisions noted above. Once you decide on the message, don't ever water it down.

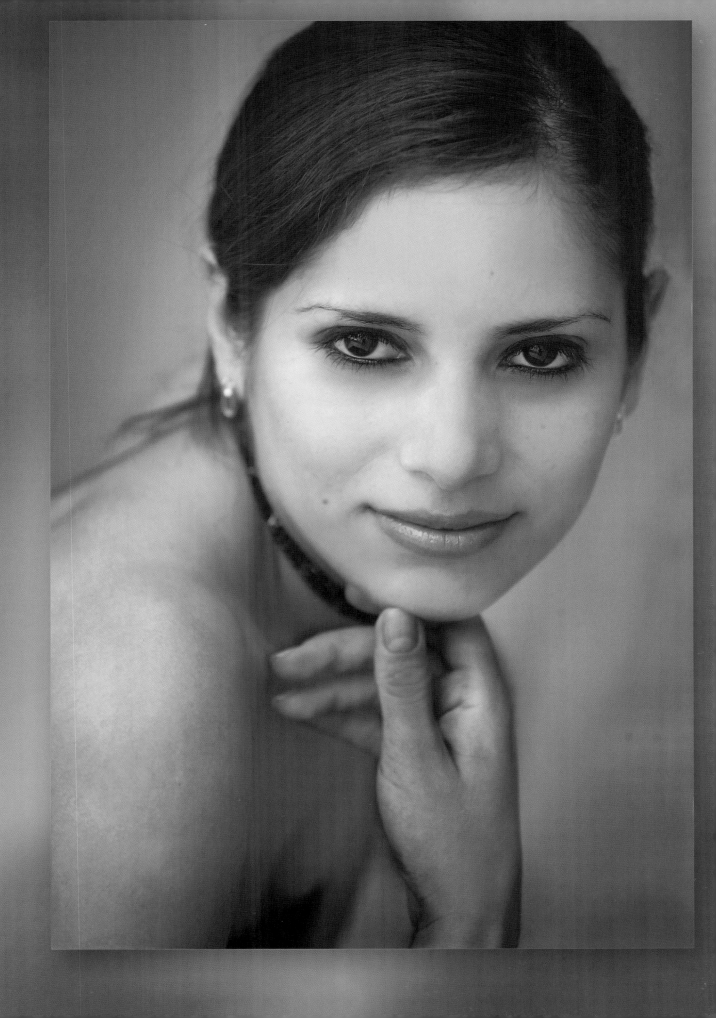

7. VICKI TAUFER

Vicki and Jed Taufer operate a very successful studio in Morton, IL, a town of 17,000. They also market to two larger cities and many small towns. Their V Gallery reception room resembles the social center of an exclusive club. This is part of the special brand the couple has created for their business, which grew quickly from a basement studio to three camera rooms in a 6,800-square-foot building they own. Vicki is the shooter, and Jed handles the business and production areas. Both are popular seminar and convention speakers. Vicki (who was interviewed for this chapter) says,

"Now I enjoy having employees doing the work I used to stay up late at night finishing." To learn more about Vicki, please visit www.vgallery.net.

Describe your background.

I received my first photo education in high school. When Jed and I started dating he became my primary pictorial subject. I only took one photography class in college, but after I graduated I took a business class, which helped me create a detailed photographic business plan. I joined my

state photographic association along with PPA and discovered some amazing people. My main mentors at the beginning were Darton Drake, Tim Kelly, and Tim and Beverly Walden. Over the years we've become friends, and I continue to admire their work and business sense.

In 1999, we decided to open a studio in our home basement, and within a year we signed a five-year lease on a 2,500-square-foot space that needed complete remodeling. With help from family and friends we did most of the work, and a year later we expanded the space and went digital, and Jed came on full time. We added on to the studio the next year and employed a second photographer who focused on babies and limited-edition sessions. I took care of children and families as well as seniors and some weddings. The following year we spoke at some small events and entered some competitions.

In 2005, we received several awards. That led to more speaking engagements, including one in South Korea. At that point, studio consultations we had begun for individual photographers become well-attended workshops. In 2006, Jed and I spoke widely, including engagements in Italy and the Philippines. Speaking and workshops have become an important part of what we do. We also have an educational retreat called Haven. In college both of us expected to be teachers, so it has been a real reward to regularly teach photographic subjects.

Children's and family images make up half of our business. The remainder is high school seniors and weddings.

Who are your influences and mentors?

Our mentors include Sandy Puc', Dave Junion, Michael Taylor, Sana Antisdel, and Kia Bondurant. All have become good friends; we are lucky to be able to use them as a resource for our photographic and business questions and appreciate their empathy.

Describe your studio.

We have a 6,800-square-foot studio with a lot of window light in three camera rooms. Currently V Gallery is operated by Jed and myself with the help of three full-time employees: an office manager, a graphic designer, and a salesperson. We employ a second photographer part time, and my sister Michelle does retouching, bookkeeping, and is webmistress.

Our studio was designed and decorated to look and feel like a boutique so clients might feel our fees were worth every penny. Recently we've expanded the studio by over 3,000 square feet to create Haven, our educational retreat. The space also doubles as two more camera rooms. In the last two years we've hosted over a dozen workshops, and we plan to do about twenty more over the next eighteen months. For more details, see www.vgalleryhaven.com.

Jed and I have made sure our roles are well-defined. I am the primary photographer, and I mainly shoot in the studio, usually without an assistant. I take care of most (brand-based) marketing for the studio. Occasionally I

take Jed with me on location. He's a jack-of-all-trades in charge of everything technical.

Do you have a philosophy that guides your approach to fine portraiture?
My philosophy centers around making sure clients are comfortable and enjoying the session experience in an atmosphere where they can relax and be themselves. This is an important part of my style and may even be my defining attribute. We love to hear that a husband or father has enjoyed his time with us. That's exactly what "fine portraiture" is all about. It's more than beautiful lighting, posing, expressions, or backgrounds. It's an experience.

Describe your approach to scheduling.
Most of our sessions are shot Tuesday through Friday with a few on Saturdays. We reserve several weeks in the year to attend or speak at photographic events. We would like to take more time for ourselves, but we become over-whelmed with business opportunities. We realize taking a break has its advantages; many of our best ideas originate away from the chaos of the studio when we see things from different perspectives.

Some of our best creative conversations occur when we can think without distractions, but in the last few years, time off has usually been a day or two tacked onto a speaking trip. This is when we take most of our personal pictures. Images from Italy are all over our home and studio.

Were your early business expectations realistic?
I was pretty aggressive when I created our business plan, but I didn't really know what to expect. Starting a business was fairly easy, but managing it effectively was a completely different thing. Coming to that realization forced us to think about both the short-term and long-term effects of our decisions. And the most important decisions were who we hired to work with us. Our employees are central to our business, and managing people is very chal-

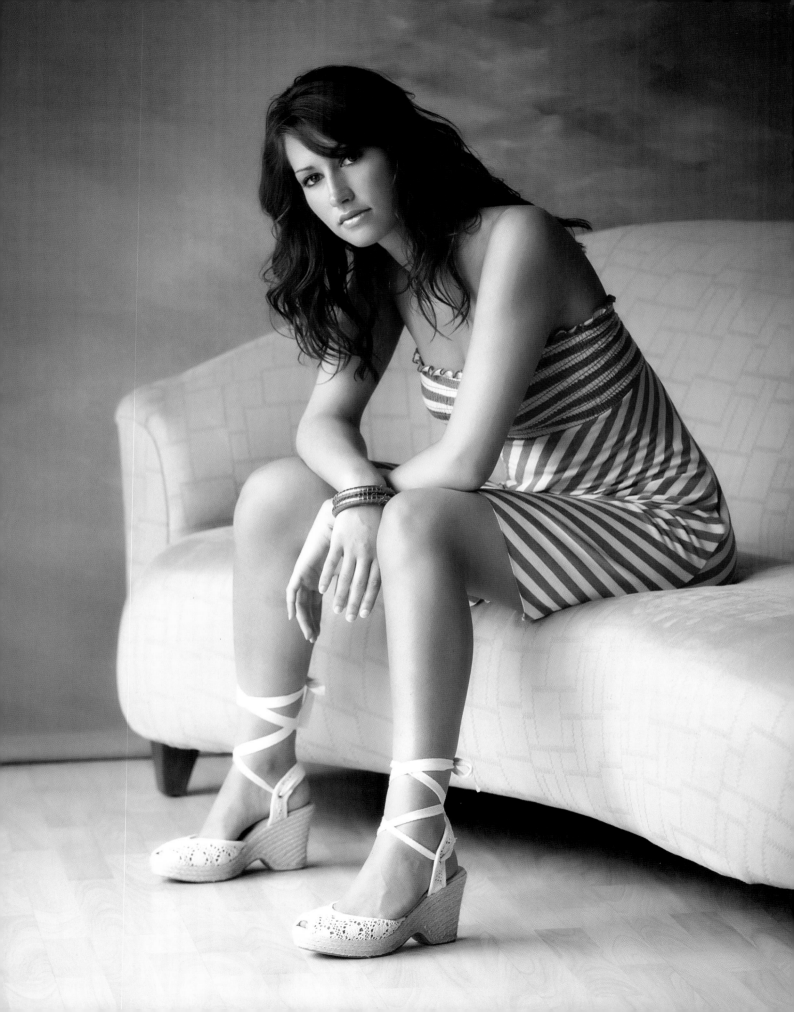

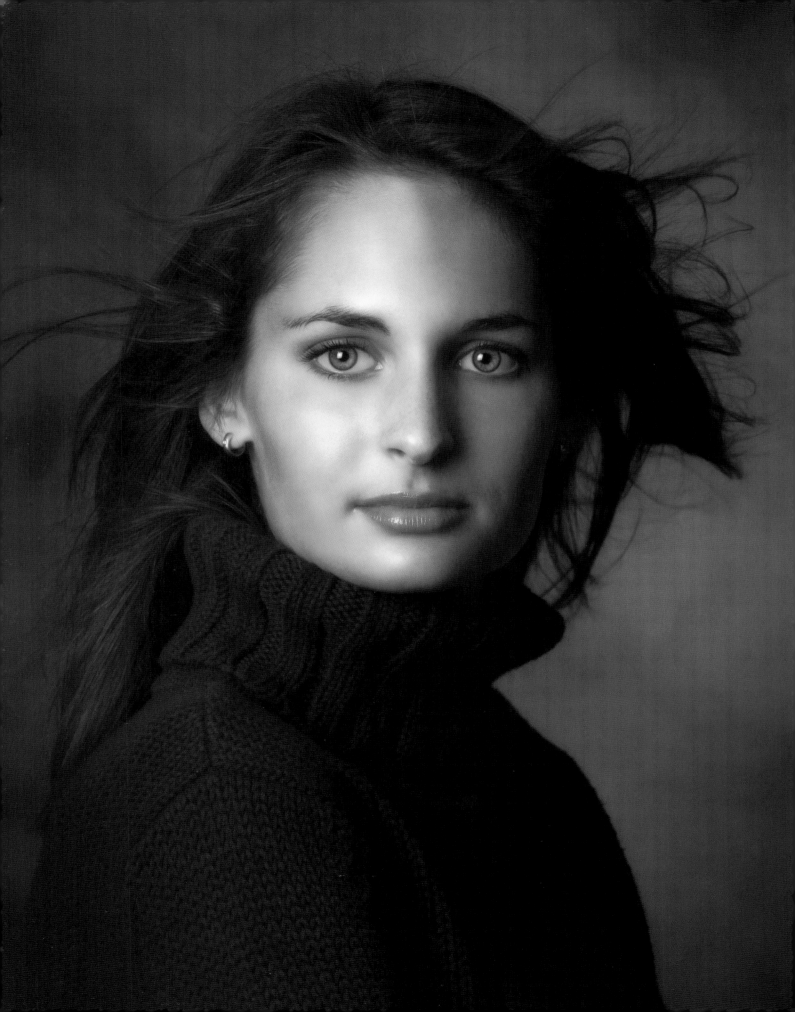

lenging for me. Jed has helped a lot because he has a tactful way with handling certain situations.

A key benefit of working with your spouse is filling in the gaps for each other; he or she can also provide support. One person's strengths can help to offset the other's weaknesses. From an emotional standpoint, a huge challenge for us is dealing with fear. It pops up out of nowhere and as our careers have progressed, using fear as a motivator has been a major sign of growth and maturity for us. It's definitely easier said than done, but as time passes, dealing with fear becomes an almost normal part of the business process, and it isn't that scary.

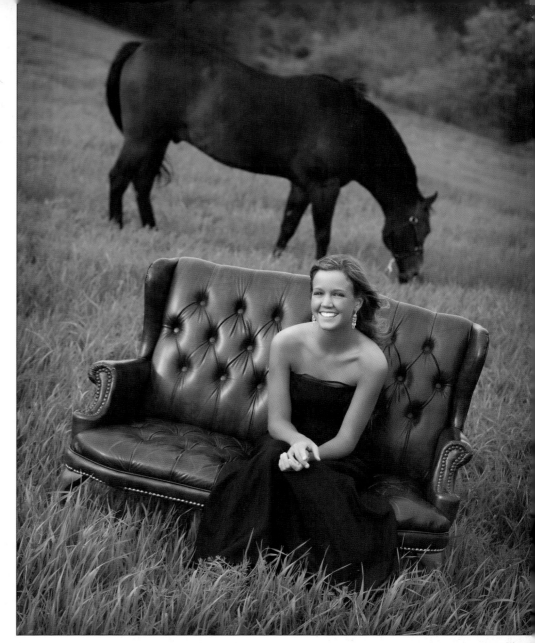

How do you approach posing?

As opposed to formal posing, I tag my style as "unposed." I see myself as the conductor of a symphony. I try to offer limited guidance and suggestions at a session, because I want subjects to do most of the "work" themselves. Sometimes I'll demonstrate what I want by posing myself, but I rarely touch my subjects in order to pose them. I've found that I can achieve a natural look more easily if I leave most of the movement and posing up to them.

What strategies do you employ to communicate with your subjects and elicit the desired expressions?

I spend much of my energy throughout the shoot just talking to and encouraging clients to make them feel comfortable. I'm not talking to distract them but to encourage them to open up and relax. Jed has helped me quite a bit as he is very good at read-

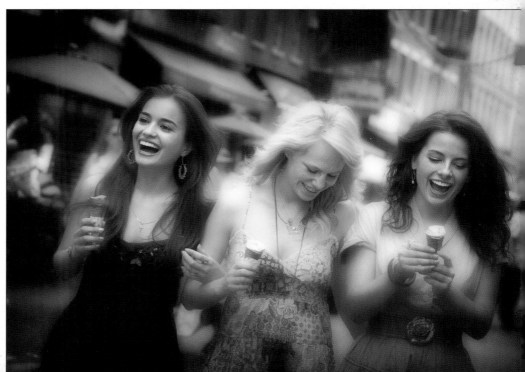

ing people. If I'm having trouble with a family or even a small child, I'll ask him into a session. He has a way of making people laugh and open up.

Smiles. Often the easiest way to get someone to smile or laugh is to tell them not to. Or ask for a fake laugh that usually turns real. This works for all ages. I get some of my favorite images this way. With shy people I pay close attention to help them get comfortably involved. However, some people will never be at ease being photographed, and as an antidote, I offer the most pleasant experience possible.

What lighting equipment and approaches do you favor?

My stance on lighting is to keep it simple so I can focus on relating to the client. Half of my sessions are photographed with a large north window light, and I bring in whatever backgrounds or furniture I need. When the weather or time of day excludes daylight, I photograph with Larson 4x6 and 3x4 Soff Boxes with Photogenic strobes because they mimic window light. I also use Larson reflectors. My light is usually to the left of the subject creating a wall of light. I can angle a reflector to either add or reduce the light.

What type of backgrounds work best for you?

My favorite props are couches, mostly purchased at estate sales. I also love working with rugs and fabrics. My favorite background companies are Robert Andrew Designs, PhotoShowcase, and The Shooting Gallery (formerly Les Brandt Backgrounds). I use both painted muslins and canvases, but prefer canvases on my roller system, which is easy to use—plus, the backgrounds don't get wrinkled.

Do you conduct any location sessions?

We photograph most high school seniors and large family portraits on location. We listen to our clients' needs during a consultation to better create the type of session that's best for them. Outdoors we use available light and reflectors, and only rarely do I use flash. For seniors, my favorite locations are usually old buildings downtown. I

also enjoy an easily accessible lake and waterfall on twenty-five photogenic acres. Six months of the year we pay to use a 50,000-square-foot warehouse with a lot of great shooting spaces and window light. It's popular with families and high school seniors.

Do you create environmental portraits?

Though 80 percent of V Gallery portraits are photographed in the studio, a specialty is the Real Life ses-sion. We photograph a family or child on location in their home or at a favorite spot, and we include a black & white coffee-table book with the session.

Which cameras and lenses do you prefer?

We use Canon cameras and lenses, most often the Canon 5D and the Canon EOS 1Ds Mark II. We have many lenses, but my two favorites are the Canon 70–200mm f/2.8 and the Canon 85mm f/1.2.

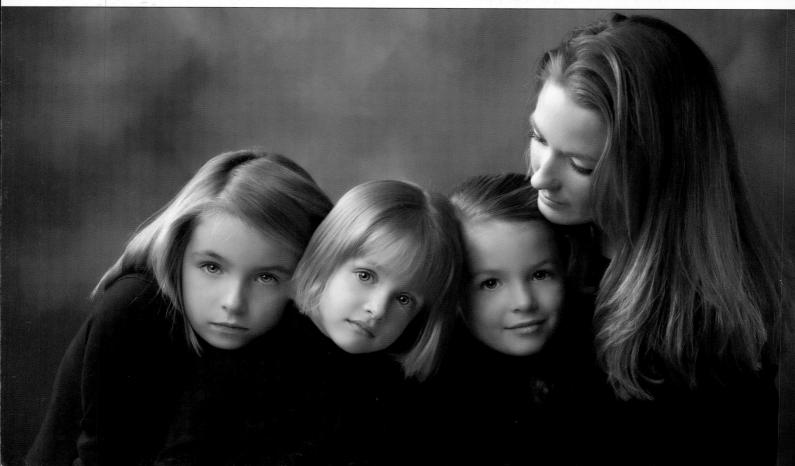

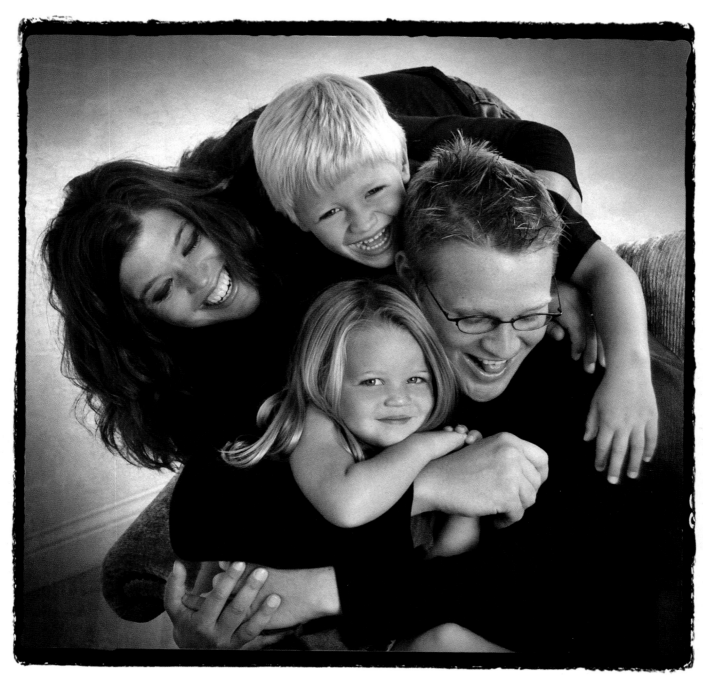

Do you sell many black & white prints?

V Gallery offers color, black & white, and sepia for finished images. Thirty to 40 percent of our family portrait sales are sepia. We show many images in sepia in our gallery displays, and it has become a signature look for us. You will sell what you show.

Describe your workflow.

Four of our staff have graphic design skills that allow us to edit and enhance our images in-house. We outsource all printing to White House Custom Colour. It has been

very important for us to have close relationships with our vendors and take care of each other. Besides traditional printing, we are able to get products such as gallery wraps, metallic prints, and press printed products, all from the same location with the same great customer service.

How are your clients' images presented?

All sessions at V Gallery are sold through projection by a dedicated salesperson in a comfortable room where we showcase all of our products. For our sales software we use ProSelect, which helps us stay organized and sell big-

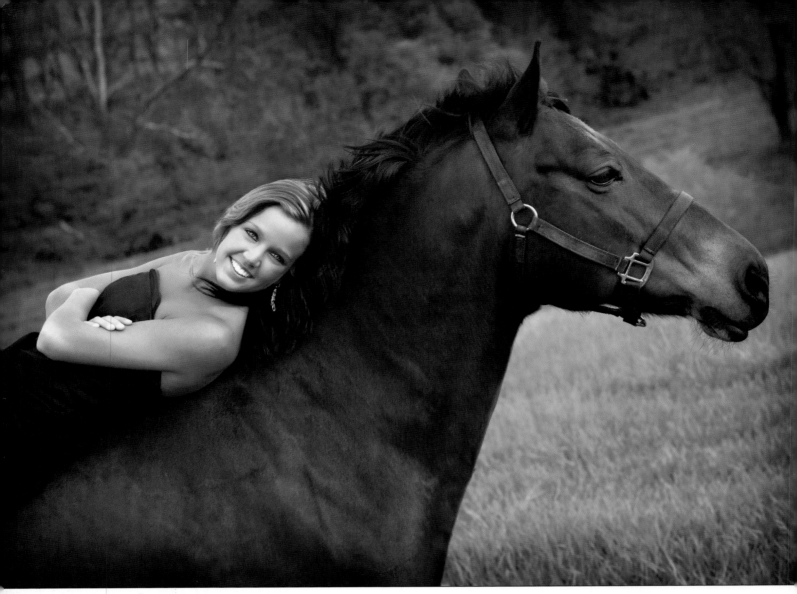

ger, better, and easier. It is important to make this part of the process relaxing since it might take 1.5 hours. We offer refreshments to clients sitting on our comfortable furniture. Sales doubled when we switched to projecting. It enhances the education of clients about appropriate images and sizes. We sell various albums, some outsourced, others assembled at the studio.

How do you structure your pricing?

All portraits and products from V Gallery are à la carte, with the exception of one package called Masterpiece Collection, which can only be ordered after a client has invested in a minimum order. The package includes four poses and eight classic gift prints, which are images 8x10 inches or smaller, all priced the same. This has simplified our pricing structure and allows us to avoid standard crops in favor of crops that look best.

All our wall portraits are priced from the longest side. For example, a 10x20-inch print costs the same as a 16x20-inch print. Most of our clients purchase a wall portrait, but our sales averages are raised by offering add-ons such as coffee-table books, collages, jewelry, and handbags. V Gallery is higher priced than most other photographers in our area. We used to raise prices multiple times a year, until we arrived at our current high level, but we switched to once a year.

How do you promote your studio?

We promote our studio through two main concepts: relationship marketing and event marketing. Relationship marketing is when we work with other businesses in the same market niche and display images in their stores. We also build relationships with the owners and employees. We send them business cards and gifts for the holidays.

We photograph their families so they can fall in love with the experience we offer. We advise following up on a regular basis. Our best displays are in women's and children's clothing boutiques plus spas and hair salons.

We also do event marketing, which gets people in our community talking about our studio. One of our biggest annual events is Girls' Night Out. When we host this event on a February evening, twenty-five vendors sell everything from handmade jewelry to clothing and mini neck massages. Each vendor pays $50, brings food, advertises the event, donates an item to the 250 gift bags we give away, and donates a large item for a raffle. The proceeds are given to a charity. V Gallery promotes new products and offers special prices on frames and sessions booked. Of the average 300 women who attend, thirty will book sessions. If you don't have a large studio space to host such an event, share the costs by hosting with another business in the same niche market.

Web Site and Blog. Both web sites and blogs are great marketing tools. My sister handles them in-house. We have considered outsourcing some of the web site, while maintaining control of content. V Gallery also offers four to five limited-edition specials a year for Mother's Day and Christmas, which includes holiday cards. Year round we offer the Bebe Collection; my associate photographs a baby three times during the infant's first year. Clients also buy matted images, collages, and coffee-table books from these sessions.

We donate to numerous auctions and charities that agree to return our display. We also donate our time for a variety of nonprofit organizations.

Are there any business details you'd like to share?

The first two years we put our money back in the business, but for the past six years Jed and I have paid ourselves a salary. We also put retirement funds away from each paycheck. It is important to have money saved to fall back on.

How important is a photographer's personality to his or her success?

Communicating is very important to successful portrait photography. When clients pay for sessions, they expect us to responsibly make them feel comfortable. They expect their portraits to include honest and true expressions. Some clients have told me about negative experiences they have had with other photographers whose personalities seemed indifferent. Being aware of the experience you offer your clients pays off in mutual satisfaction as well as income.

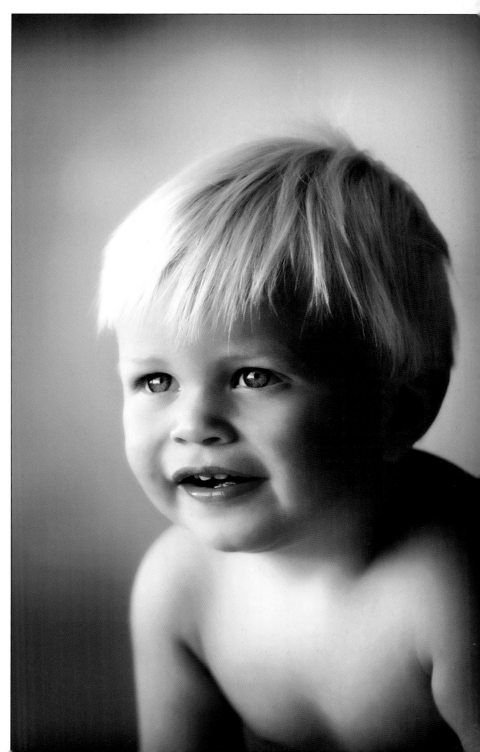

8. CARL CAYLOR

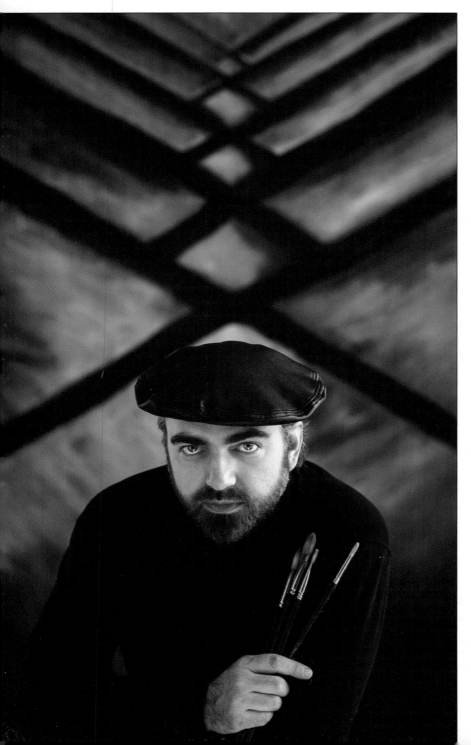

Carl Caylor's studio is located in Iron Mountain, MI, though his clientele is from a wide area. He describes himself as an artist who chooses the medium of photography. Portraiture, he says, is both art and family history. He creates portraits of families, high school seniors, and children. He is PPA Certified, a Master Photographer, Photographic Craftsman, and Kodak Mentor. He conducts professional photography seminars and has won many national awards from Kodak and Fuji as well as fifteen PPA Loan Collection images. A former Wisconsin resident, he was Photographer of the Year two years in a row in that state. To learn more, please visit www.photoimagesbycarl.net.

Describe your background.

I was introduced to photography by my aunt and uncle, and later by my high school yearbook advisor. Love and passion for photography took root, and I studied it at the University of Wisconsin–Platteville, where I worked for the university while pursuing my BA. I also shot for several newspapers and portrait studios and did custom darkroom work. Photography has always been my true occupational calling.

How long have you been in business?

I have owned my own studio since 1995, originally in my hometown of Pulaski, WI, where I converted an old shoe and clothing store into a natural light studio. I've always specialized in portraiture but also do weddings and occasional commercial work.

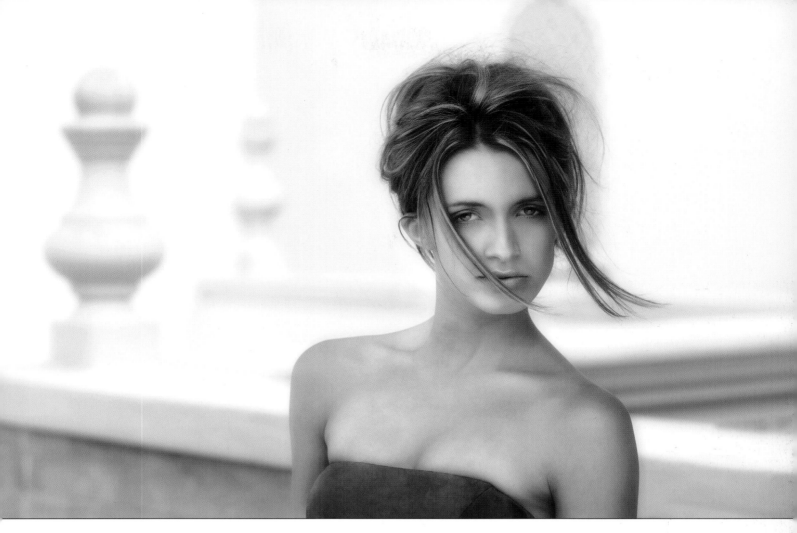

Who are your influences and mentors?

I have been greatly influenced by Jay Stock, Scott Dupras, Darton Drake, Fuzzy Duenkel, Mille Totushek, Donna Swiecichowski, Teri Shevy, and others. From an artistic standpoint, I have been inspired by the French Impressionists, as well as painters such as Andrew Wyeth, Steve Hanks, and Norman Rockwell.

Describe your studio.

In Iron Mountain, I designed and built a 5,000-square-foot home and studio around a north light camera room measuring 24x36 feet with 26x18-foot windows. I have no full-time employees, but I occasionally employ co-op students in a work study program for a few hours. Most of my portrait sessions are done by myself or with the assistance of a parent or friend of the subject. My wife, Theresa, helps with client consultations and office work.

My high school senior sessions include in-studio and on-location portraits. I prefer to photograph a family in a wooded area by a stream or in another scenic spot.

Describe your approach to fine portraiture.

If beauty was only skin deep, every photograph would reveal the same personality. An artistic expression in a portrait goes past the outer layer, beyond first impressions, and into the depth of one's defining essence.

My philosophy for sessions evolves. I find a location with good quality light and a great background to create depth and dimension, to help tell the subject's story. I then let subjects exist in that space and be themselves. I try to be intuitive about their personality as quickly as possible so my words, actions, and body language encourage them to be natural and comfortable. I strive to improve my artistic skills to make my style recognizable.

How do you approach your sessions?

Clients' consultations are scheduled to discuss clothing, ideas, locations, etc. We create images during daylight hours. Senior sessions are done both in-studio and on location. My Fridays are reserved for production work or family time. Image presentations, sales, and more pro-

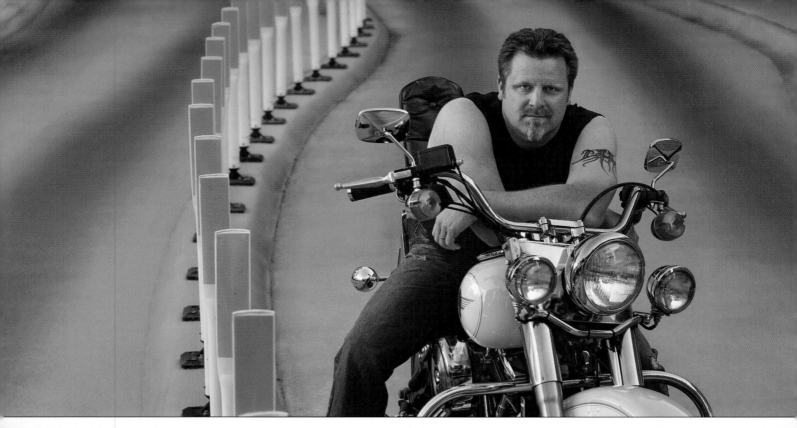

duction work are done after dark. I do fewer weddings now, so occasional family portrait specials are done on weekends.

I constantly take client portraits for myself in order to experiment artistically, for display purposes, competitions, or to test new equipment and software. Additionally, I annually photograph my family for Christmas cards. Shared with clients and friends, these images become powerful advertisements.

How do you approach your teaching?

I began a speaking career in 1996 while pursuing my PPA Photographic Craftsman degree. A Kodak rep who attended one of my programs asked me to join the Kodak team, and since then I have become a Kodak Mentor. The company sponsors some photographic schools and conventions, but I choose where I go and they pay the organizations directly. Payment as a speaker doesn't come close to what I can make in the studio, but my goal is to

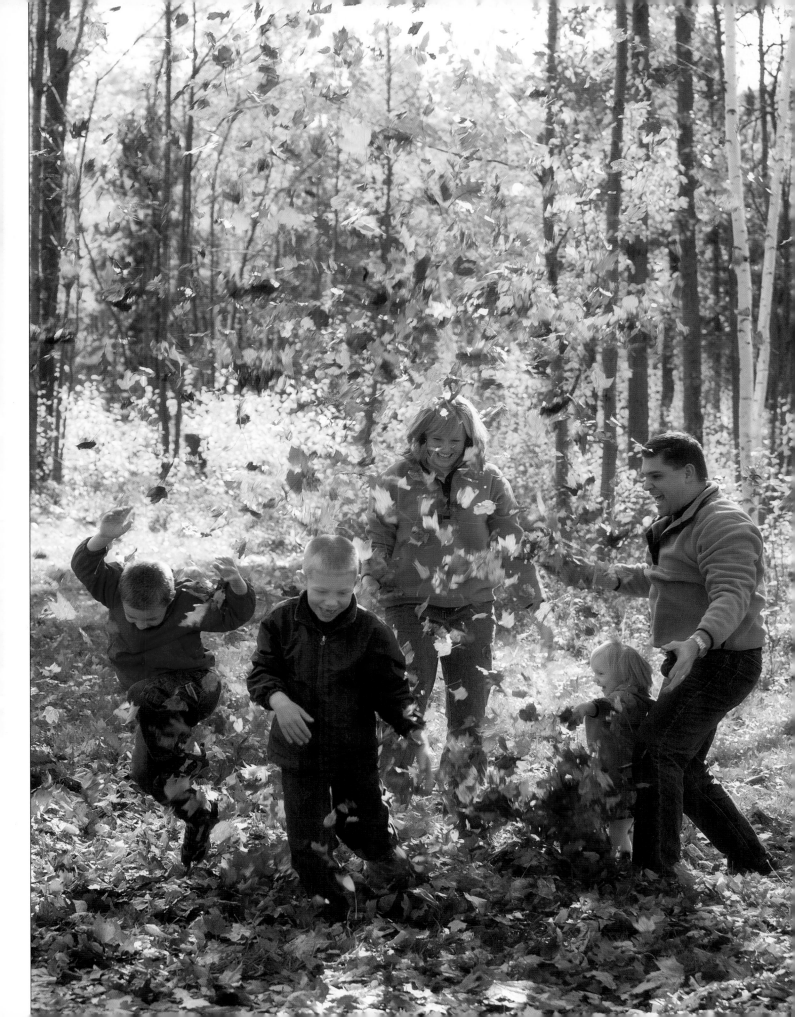

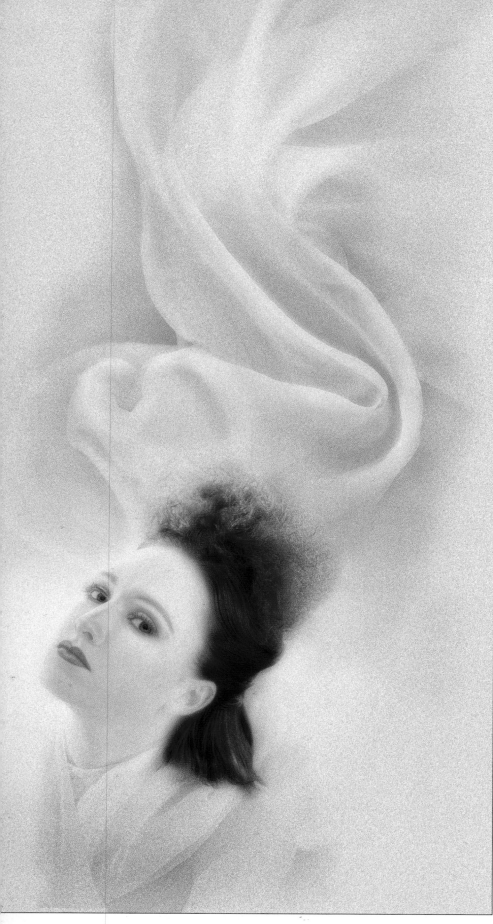

give back to the photographic industry and continue my own education. My speaking curriculum stays consistent throughout the year but evolves to include new technology and expanded knowledge. Many other professional photographers speak in the "circuit" on various topics. I learn a lot by being around a diverse group of talented speakers.

My programs cover human cognition, portrait lighting, composition, emotional elements, color harmony, style, storytelling, etc. The topic I find to be most misunderstood lately is basic camera techniques. Photographers need to understand camera functions to produce the visions in their imaginations. In weeklong classes, we combine lectures and hands-on photography with models and location setups so students learn the psychology of photography as well as techniques.

Were your early business expectations realistic?

My early business expectations were not necessarily realistic. I tend to set high goals, so even if I don't reach them fully, my efforts are still successful. One early decision I still adhere to was to consistently provide a quality product and memorable experience for my clients. I worked for years before I actually considered myself a professional photographer. I am passionate about anything I do, so it has been an emotional roller coaster. I invest my time, talents, and heart in all my sessions and all my images. Many professionals find that it's difficult to produce art while needing to run a financially profitable business, but it can be done.

How do you approach posing?

Posing is about composition. It's about storytelling. I let clients pose themselves, and then I tweak them so they are photo-

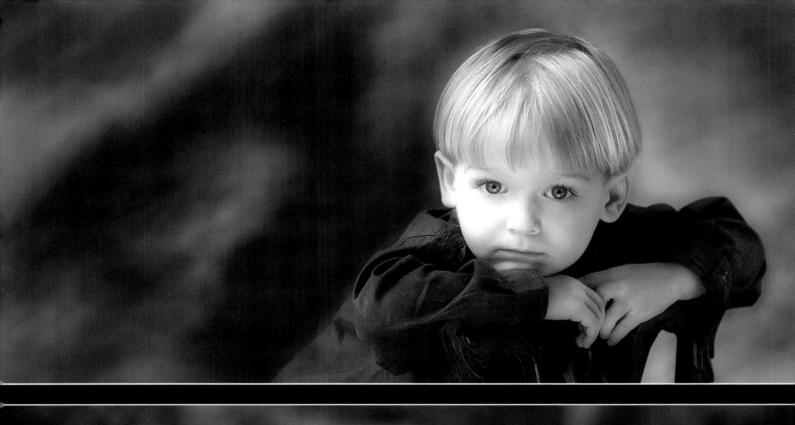

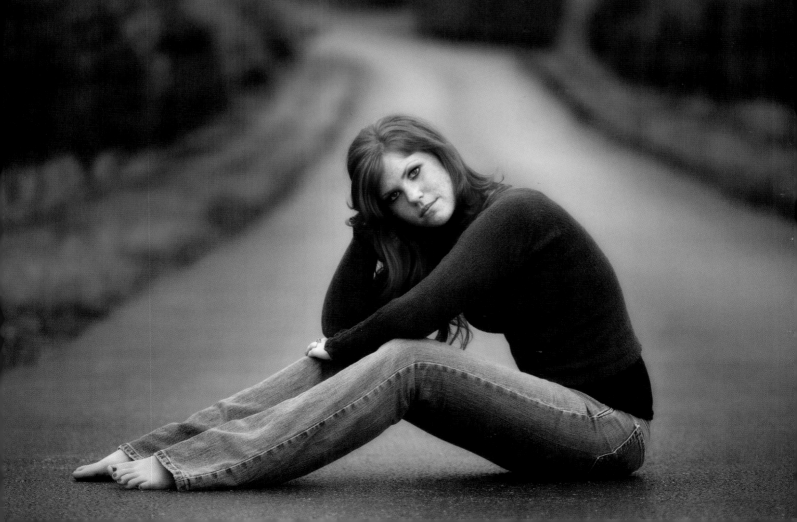

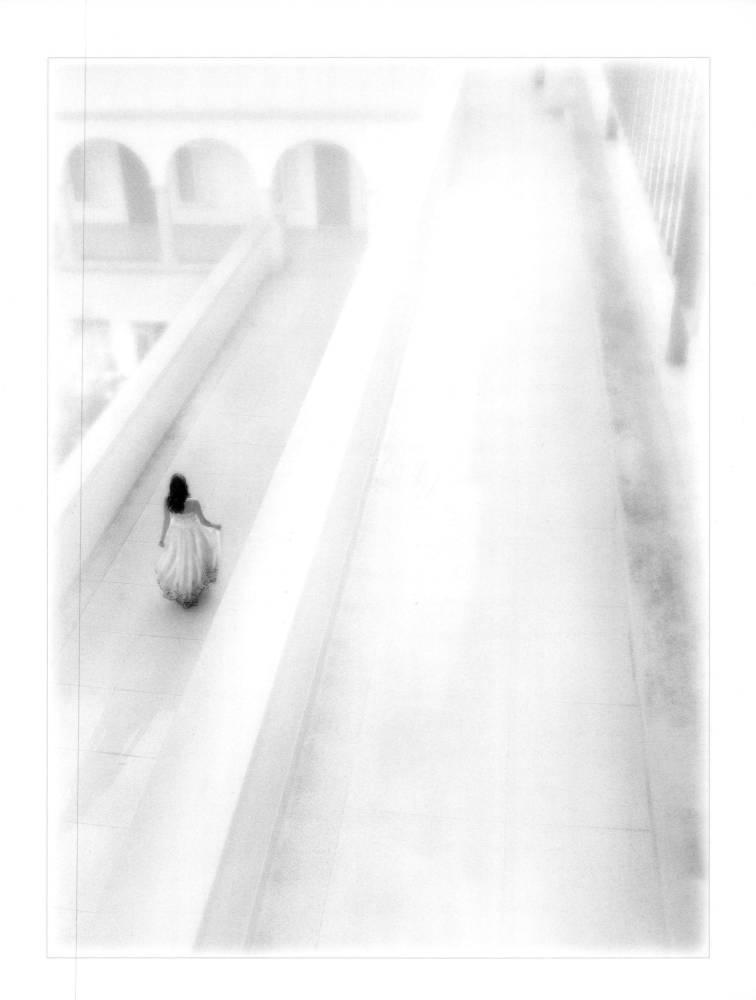

graphically correct. I look for angles and curves in body parts, hair, and clothing to emphasize what I want viewers to see. The pose must then be lit in such a way that it harmonizes with the facial expression or emotion of the subject's body language. Subject and environment colors should work together. Everything within the image should help tell the subject's story.

What strategies do you employ to communicate with your subjects and elicit the desired expressions?

A successful session is all about psychology. It's helpful to start with a discussion about the person prior to creating images. Get to know their likes and dislikes to sense their personality. Teamwork helps reveal the subject's true story.

How much I may or may not talk depends on the subject. I want children to get bored so I ignore them, and they entertain themselves and show their true personality.

Large family groups require more orchestration to ensure pictures are made in a timely manner. My experience in coaching athletics has helped me command attention in a positive and constructive way.

In any session, you need to communicate confidence in your artistic skills and your knowledge of equipment. If you seem nervous or confused, your subject will react negatively. If you are comfortable and congenial during the session, you are seen as cool and professional.

Our high school seniors love the unique style of my work. In their referrals, they tell friends they had a great time, felt really good about

themselves, and loved the pictures. Variations on these sentiments are true for most types of my portrait sessions. When a mother thinks we ended with nothing after a session with an uncooperative child, and I present beautiful wall portraits they love, I feel rewarded. Sometimes it's a game of patience, and I hate to lose.

Smiles are highly overrated, though at times they are important, and they are typical in albums or on a shelf or desk. Wall portraits, however, require a more natural, pleasant expression that tells more stories. Expressions are like reading between the lines of a good book where you can use your own imagination. Smiles may allow only one story—happy—and it will get old eventually. When I do want a smile, I ask the subject to giggle or to tell a story that produces a happy feeling. Specifically asking for a smile may create a corny grin, resulting in an image no one wants to buy.

I photograph shy people by talking quietly and moving slowly. It's all about your body language and conversational skills. Let the subject warm up to you gradually, and use the extra time to make them comfortable.

What lighting equipment and approaches do you favor?
I specialize in natural light photography and look for lovely light that adds to the mood of a session, especially with happy people whose facial features—eyes, nose, mouth—we want to light. More somber expressions can be broadly lit, leaving parts of the face in shadow. Soft light is required for soft subjects. Harsh shadows produce stronger or more sculptured looks. Lighting should match the story being told.

Wraparound lighting is a myth. Light does not wrap around, because it always travels in a straight line. The length of your light source, such as a softbox, gives you

the effect of wraparound light. When you use the edge of the light source, light should skim across a subject. This is the only way we can create texture and shape on a human face at the same time.

What type of backgrounds work best for you?

In my studio there are many canvases, muslins, and fabrics. I painted many myself and purchased others from Shooter's Gallery Backgrounds. I have no permanent sets, and I use only a few props such as a chair or a favorite item the subject brings. I keep things simple, because sets can easily get you into a creative rut using the same backgrounds and poses with different faces.

Do you conduct any location sessions?

I look for architectural and graphic elements that create depth and harmonize with the subject's coloration, personality, style, etc. At some times of day the light requires us to switch to different areas within a location to guarantee greater variety.

Usually I look for open shade with open sky. The sun is our enemy. For large groups and family portraits I prefer soft outdoor illumination. Using a location that has meaning to a family helps create a better experience than an in-studio session.

Do you create environmental portraits?

These are a large portion of my family and high school senior photography. During client consultation we discuss this type of portrait, which helps create a more memorable experience. These settings also generate more profitable wall portraits and draw more word-of-mouth attention.

In my studio, we do not deal with standard 16x20- or 20x24-inch prints. Wall portraits are sold as 20- inch prints, 24-inch prints, 30-inch prints, etc. As the artist, I can present the image in the proportion that suits it best.

Which cameras and lenses do you prefer?

I use Canon 1DS Mark II and Canon 5D cameras, with Canon 70–200mm f/2.8 IS and Canon 16–35mm f/2.8 lenses. A longer lens with its narrower angle of view allows you to make backgrounds less distracting. In group shots the long lens allows subjects in the foreground to stay more consistently sized with subjects in rows behind them.

Do you sell many black & white prints?

This is a big part of my signature series portraits. I use my darkroom experience to create custom black & white canvases. There should be a reason for black & white, such as to enhance an emotion, subdue a color to create

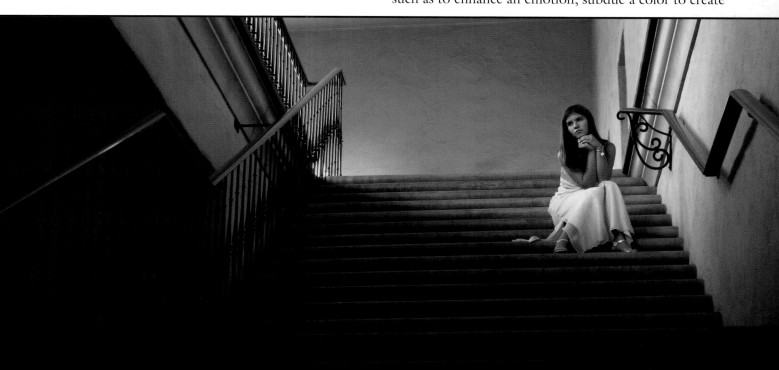

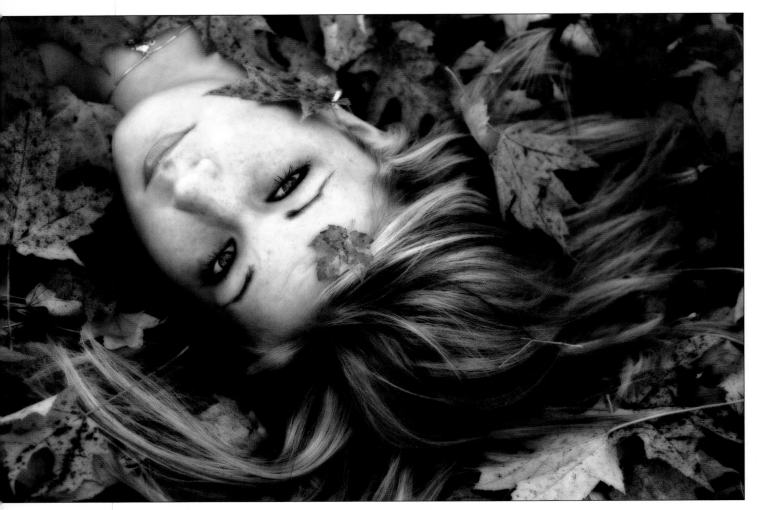

better harmony, or to emphasize areas that color might pull a viewer's attention away from. Black & white can make a powerful presentation.

Describe your workflow.

I photograph in raw format and convert to JPEGs for editing and image presentation. After an order is placed, I convert raw files to TIFFs, which are retouched and custom enhanced in Photoshop for print preparation. Some images are softened or given other effects, like Nik filters, prior to printing. Images are saved with the client's raw files on a set of external hard drives for reorders or future reference.

Black & white canvas and watercolor portraits are sent to my in-house Epson 7600 inkjet printer. All other photographic images are done by White House Custom Colour Lab, which also has a press printing division where we design and order graduation, holiday cards, and business cards, bookmarks, and posters. Recently the lab has begun printing albums, and we will again expand our product line.

How are your clients' images presented?

We do not believe in using traditional paper proofs, which can be easily copied. Copyright laws are misunderstood or ignored, so we prepare an electronic slide show projected larger than life size. After the show we open all of the images and, with the clients, we edit down to their favorites, especially where expressions are concerned. We also make suggestions about which images are best suited for wall portraits, gift sizes, wallets, black & white, canvas, or watercolor.

Prior to presentation we print a book with a Xerox Phaser 8400 laser printer that uses solid wax inks and produces smooth, photo-realistic images. Prints are four on a page with copyright markings and file numbers. This is done easily with an action set called QuickProofs, which we purchased from John Hartman.

After editing we mark images in the client's Xeroxed book to help them make final decisions. A proof deposit is collected and credited toward orders if placed in a timely manner. We also make an appointment for clients to return to order. We display the albums we design, but most are printed and/or bound by professional publishing firms.

How do you structure your pricing?
I do not care for portrait packages because I feel clients should get exactly the images and sizes they want. There is always a demand for 5x7- and 8x10-inch prints, plus wallets. Our most popular wall size is a 20-inch print.

In our area we are perceived as being very expensive, but many clients are delighted to find that our distinguished prints are actually close in price to some from other studios. Those who come to us do so for our artistic quality and for the rewarding experience they have heard about—expensive or not.

In the last five years, we've only raised prices twice. You need to know your market area to determine what to charge without pricing yourself out of business. For example, there are only 463 high school seniors in my area, with thirteen studios vying for their business. Most of those studios charge half (or less) what we do, so we are careful to price prudently. In a larger community, my prices could be two to three times higher. Your research will help you discover what people are willing to pay.

You need to know your costs and profit margins. I believe many of our competitors will go out of business

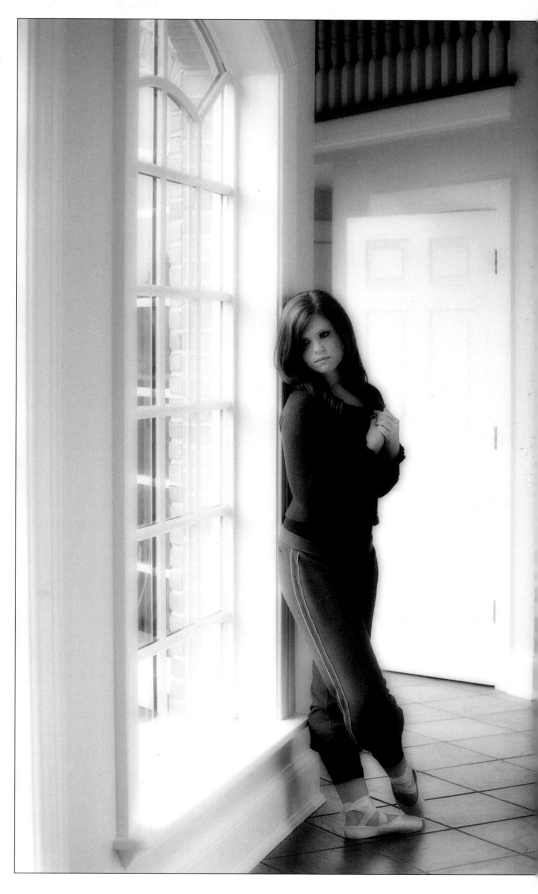

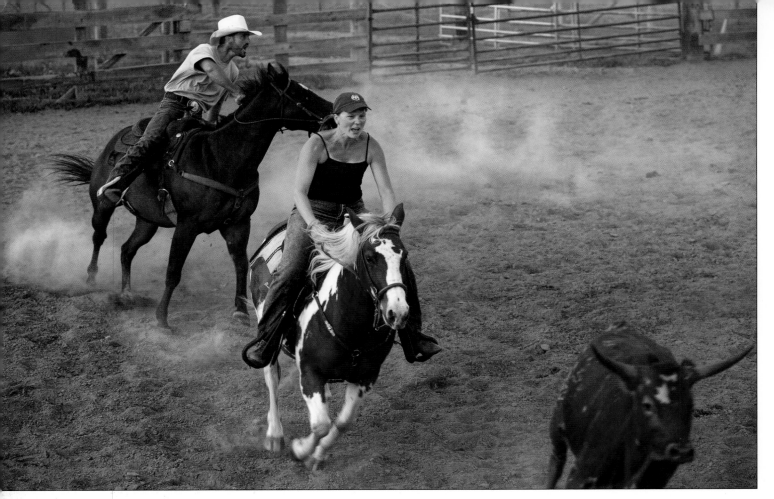

because they do not consider their true costs. They think mainly about what they are "taking in." However, while they're around they impact what our market will bear.

While our lab costs have decreased over the years, other costs, including equipment and travel, have increased. Time has become a huge "cost" too. I could spend endless hours doing image enhancement and artistic design, but at what return? Time truly is money.

How do you promote your studio?

Most of our promotions are word of mouth. We also have displays in a mall, at a birthing center, and at area clinics. We direct clients to our web site, which we update ourselves. On occasion we send direct specials to high school seniors, plus special session announcements for families and children. We also offer sessions for local fund-raisers and auctions. We cannot write off donated services, but we can deduct product value.

Are there any business details you'd like to share?

I created one business plan for my Wisconsin studio and another for my studio here in Michigan. We did another business plan in 2007 to address new technologies, new product lines, and the changing market. We incorporated in 2006, and I'm now paid as an employee, which offers tax benefits and helps protect us from liability risks.

How important is a photographer's personality to his or her success?

Personality is a huge part of my business, though I am familiar with photographers who lose business because they lack the ability to communicate. Photographers with a lot of outside interests relate better to clients because they understand their likes and dislikes. In my seminars I tell photographers to listen to different types of music, travel widely, and try not to be too opinionated. It's kind of like dating: the more you have in common with people, the better you'll get along. Expand your frame of reference and you'll connect better with others.

The more we can understand about human cognition, the better we'll understand why people like certain images and which ones tell them stories. Basically, we need to learn how to mess with people's minds in a nice way, visually.

9. JOSHUA KESSLER

Joshua Kessler lives in New York City. I discovered his editorial portraits in *AARP The Magazine*. The article was titled "10 People Who Improved Our World," and among the individuals profiled were Michael J. Fox, Naomi Judd, Dr. Norman McSwain (a hero during Hurricane Katrina in New Orleans), actress Jane Kaczmarek, Harry Belafonte, and Mike Huckabee, governor of Arkansas. Joshua grew up in Ohio, the last of six children. He works mostly on location for publications that value fine portraiture. He has recently worked in London, Alaska, Puerto Rico, and at the Sundance Film Festival in Utah. To learn more, please visit www.joshuakessler.com.

Describe your background.

I decided to become a photographer when I was six, and I still have my first camera from that time. I attended Ohio University and graduated from RIT with a BFA in photography. Equally important to my education was a year off from school to play in a band. Also, immediately after RIT I spent a year (1992–1993) working full time as a photo assistant for Annie Leibovitz. I then freelanced as an assistant for a year-and-a-half for photographers such as Josef Astor and Steve Klein in New York.

When I went on my own I claimed that I photographed bands and babies

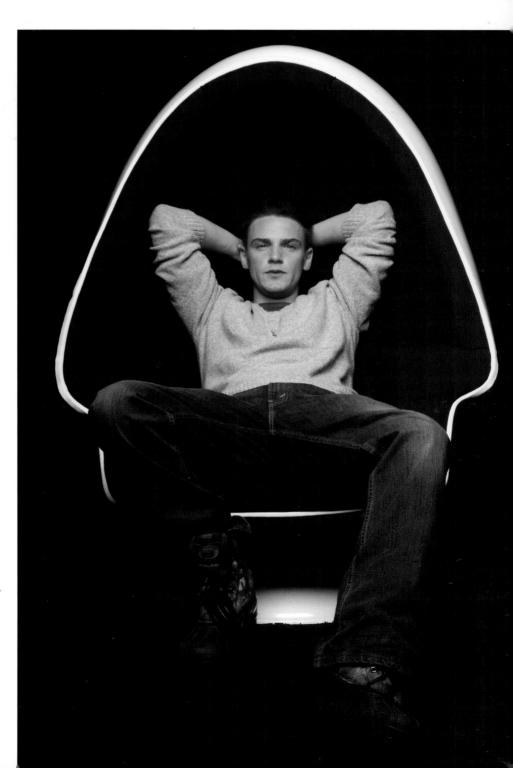

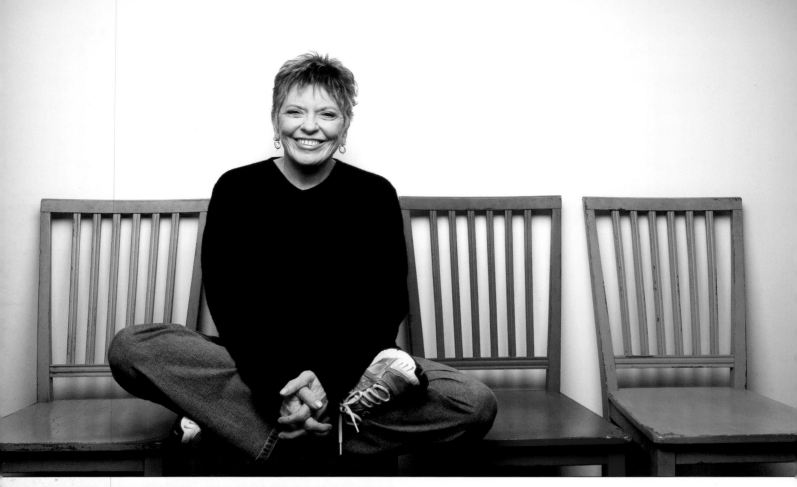

Who are your influences and mentors?

A friend of my father owned a camera store, and there seemed to be an abundance of still and movie cameras in our house. Among my early influences were my older brother, Rebel, who was in film school, and my cousin Wendy, who lived across the street and also went to RIT. In college I was fortunate to have great teachers such as Denis Defibaugh and Jim Megargee. Denis taught me how to appreciate and incorporate the vast world of photography. He showed us slides of current work and led a yearly trip to NYC to meet with working photographers. (He and his classes have visited my studio for the past ten years.) Jim taught me to shoot what you know, the art of the personal document.

Annie Leibovitz taught me to do my homework. In the editorial field, the more you know about your subjects, the easier it will be to relate to them and make them comfortable. Josef Astor and Bill Zules, Annie's first assistant during my time, also influenced me. Josef is truly an artist, and I hope some of that rubbed off on me. Most of my lighting skills came from Bill, who helped me

because my first two clients were *Alternative Press*, a music magazine, and *Child*. That helped me build my first portfolio and gain access to record company clients where I mostly did publicity photos. The two biggest album covers I've done were the Foo Fighters' second album [*The Colour and the Shape*] and John Mayer's first [*Room for Squares*].

really understand how to handle lights when shooting a variety of portrait subjects.

Describe your studio.

I can shoot portraits in my apartment, but it is more of a home than a studio, because in recent years I have photographed mostly on location. In New York there is an abundance of rental studios, and clients are happy to pay when you use them, so the overhead to own a studio isn't necessary. However, I do like personal projects and small-budget jobs I can shoot in my apartment.

Do you have a philosophy that guides your approach to fine portraiture?

The closest I have to a philosophy is that portraits are more than photographs. They are documents of conversations between a subject and myself, a collaboration during which we both contribute our unique personalities

and skills. Many celebrities are able to pose more easily than the average person. Fine portraiture tells something about the subject, compared to a passport shot, which is just visual information.

Annie Leibovitz uses what she knows about a subject to influence the vibe of the shoot. It's all about making the subject comfortable, and the better you relate, the better the chances you will make a great image.

Describe your approach to scheduling.

Unlike a studio portrait photographer who may book ahead for weeks or months, as a freelance editorial

shooter I work whenever I'm called. Some jobs come in on almost an emergency basis, when an editor or art director finds that a subject is available tomorrow and is somewhat frantic to hire a shooter he can trust. My clients realize I stay cool in such situations, and I don't pass on any anxieties to subjects, who in turn leave their problems at the door of the studio and are very professional.

Location scouting is frequently an important part of my business, but too often I have little or no pre-shoot time. On larger jobs, locations are almost always scouted a day or two ahead, and clients pay for this research time. When magazine and corporate editors do plan ahead the job is more comfortable for everyone. When an art director or editor and I are acquainted, I usually get limited guidelines. When it comes to a big advertising job, every little detail is discussed. On a last-minute editorial job I may not know what I'm going to shoot until I walk in the door. Scheduling and preparation just depends on the job. I always have at least one assistant on location or in the studio, and two for larger jobs.

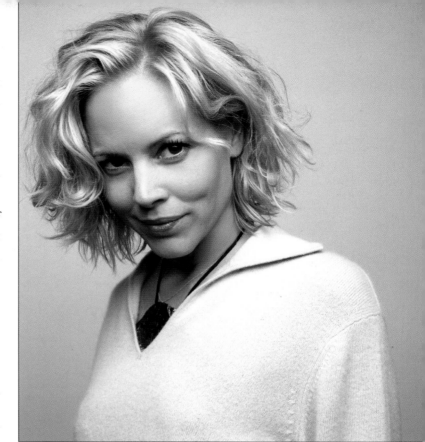

Were your early business expectations realistic?
Ignorance is bliss. I just knew that everything would work out and I would become a published photographer. However, I am constantly convinced that I will never work again, which may be good because it keeps me from being complacent. The good and bad news is that your whole world can change with one phone call. While you are waiting, you've got to keep your equipment ready to go and test new techniques. It's like going to the gym. I am constantly learning and evolving as a photographer and in business matters. I hope that never changes.

How do you approach posing?
During our collaboration every subject brings a personality and attitude that help him or her communicate with me and the camera. I tend to see what poses fit people naturally.

Generally, the first poses at a session are reconnaissance to discover what works. Sometimes I'm fortunate to work with celebrities who know how to pose, but I steer them to my views—*gently*. I learn about them beforehand, which allows me to engage them more easily and build the shoot around features of their personality. Once I have

It's true that some people can handle harsher light than others, such as a model with very good hair and makeup. I generally like a softer light that looks good on most people. I just follow two old rules. The closer the subject to the light source the softer it will be, and the bigger the light, the softer the light. As the light gets farther away I adjust appropriately.

My location gear depends on the job. The most basic setup is four Profoto 1200w/s packs, six heads, two head extensions, two Profoto globes, two custom-made medium softboxes, two large Chimera Lantern softboxes, one mini Chimera softbox, four reflectors, two C-stands, four regular stands, one silver/white flex fill, three AC extension cords, miscellaneous clamps, gels, and always gaffer's tape.

Believe it or not, all that fits into four cases and a camera bag. I use two Tenba hard cases for packs and heads, and two long soft cases for stands, softboxes, and grip equipment. I could consolidate more, but new airline weight restrictions make it necessary to even out the load. When I do not have access to power I take battery-powered Profoto 7Bs and extra batteries. The exception is when I work in Los Angeles, where you can rent anything, so I just take the camera bag and one bag with my softboxes I choose not to rent.

an idea of what they are about, I can make better decisions on posing, props, lighting, and backgrounds.

Describe your approach to indoor and outdoor location shoots.

Indoors on location I use lighting as if I were in the studio. Outside I generally mix ambient light with strobe, sometimes to add contrast. Often when I have to shoot a subject in a specific location, it's the client's request, or it accommodates the subject's schedule.

I once photographed Denise Richards at the Sundance Film Festival in a stairwell behind a soda machine. I've also shot in swimming pools with underwater cameras. The trick is to find a good location when it doesn't seem that there is one with a detail, surface, or pattern that is interesting.

Which cameras and lenses do you prefer?

When shooting film, I work with a Hasselblad 500C/M, and generally go against convention with normal (80mm) to wide-angle (50mm) lenses. When necessary I switch to a 120mm short telephoto. I handhold except when I am in a mixed lighting situation and need a tripod for slower shutter speeds to accommodate the ambient light. I shoot Fuji NPH 400 exclusively, unless the client requests transparency film. Color negatives give me the

look I like. For digital capture, I use a Nikon D2x with an 18–55mm zoom lens.

I really shoot whatever the client requests, but the more I work with digital the more I like it. I have always preferred wide angle and normal lenses because they give you a sense of space. Telephoto lenses squish things too much.

Photographers are a strange bunch when it comes to equipment. I don't think two photographers in the world have identical setups. The best equipment is what works for you and for your style. I still carry my Hasselblad on jobs even when they are digital, just because it is an old friend.

Do you sell many black & white prints?
My clients like the way I use color, so I am generally not asked to shoot black & white. I once used it for personal work, but I've switched to digital color.

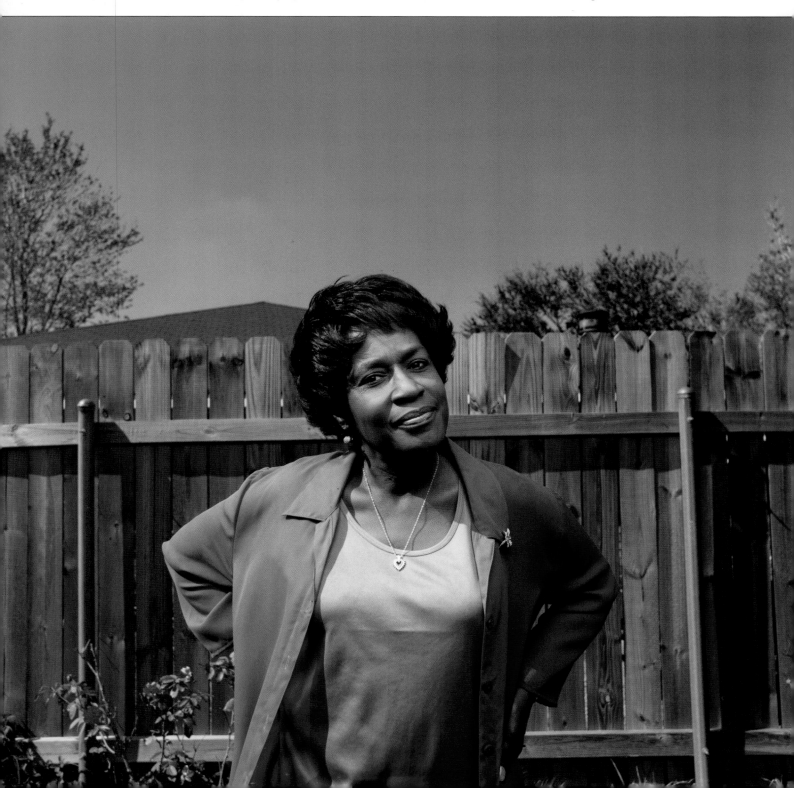

Painter Edward Hopper is an artist whose color palette has always influenced me. It is vibrant without being high contrast, much like Technicolor movies, my other main influence. I consider color as a kind of prop, whether it is seamless and taken for granted or it's prominent in a subject's clothes or home.

Describe your workflow.
I process digital files in-house and do minor corrections. I convert the raw files and do color correction and basic retouching. If extensive retouching or compositing is needed I send it to a lab. If a job was shot on film, I deliver contact sheets and then final prints to the client. If it's shot digitally, I deliver low-resolution JPEGs on DVDs or upload them to my FTP site to be downloaded.

How do you structure your pricing?
Prices vary for each individual job, depending on the usage. Fees consist of a day rate in addition to all expenses. If the image is for editorial, one-time use and I re-

important in all aspects of promoting yourself. My web site is the main focus followed by e-mail promotions, printed promotions, source book ads, and the old mainstay—going on appointments to show my work. I take time for the latter when I feel that while talking to a client, the give and take of ideas can help me cinch assignments. If they already like my work, they can be convinced to hire me at our meeting.

Do you shoot any personal assignments?

My personal work mainly revolves around keeping a photo document of my family. I am the last of six children with thirteen nieces and nephews and eighteen first cousins. I used to shoot black & white with with an old Nikon in natural light. Since I started a series of environmental portraits of my siblings, cousins, and aunts, I've used color and images are fully lighted. I have also been making digital slide shows of pictures taken during my travels.

How important is a photographer's personality to his or her success?

As noted previously, photographers should realize the advantages of skillful, cheerful interaction with the subject that makes them feel comfortable. When I interact with celebrities it's as simple as treating them like real

tain the copyright, the fee is substantially lower than if the client wishes to buy all rights, such as advertising agencies often prefer. Expenses include air fare, mileage, hotels, meals, equipment rentals, and everything related to the job that I pay for.

How do you promote your studio?

I use a combination of methods, because today synergy is people. I find something to talk about that they are interested in, other than the current project they are promoting, and I think they find it refreshing. I always consider a photo session as a conversation between two people. I need to be comfortable to work, and I help them relax, talk, and "perform" for me in a usually low-key way. I learned early on not to be intimidated, and I show my ease in the way I talk and work.

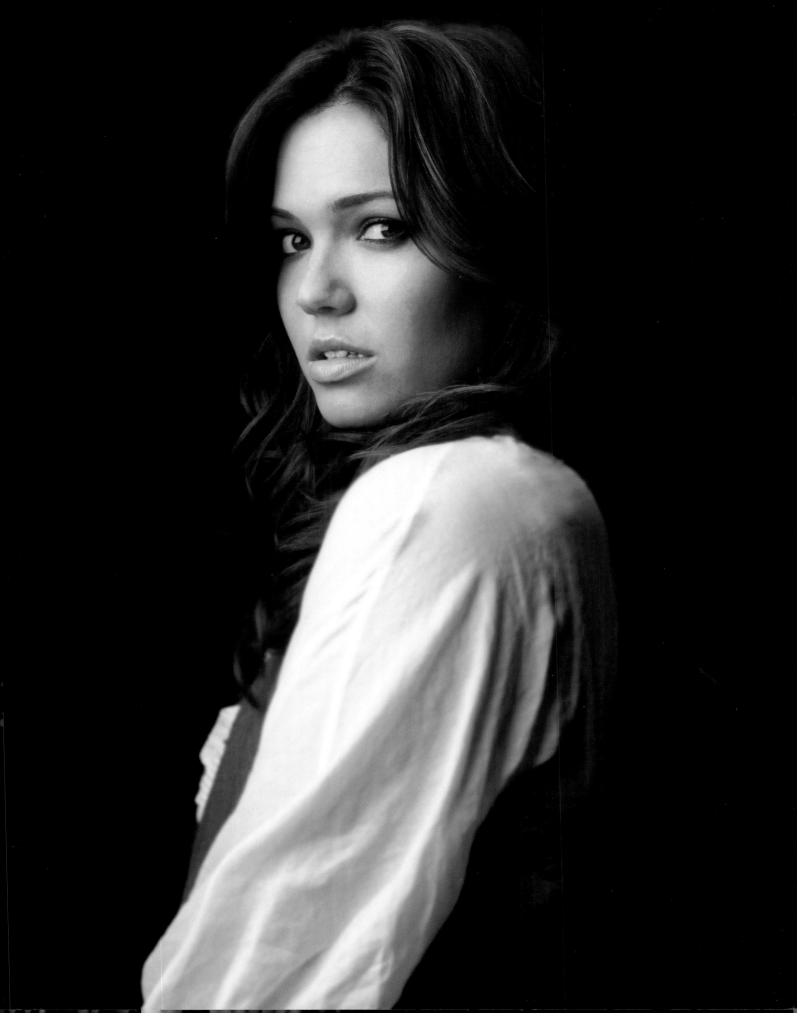

10. SIMON WALDEN

Simon Walden opened FilmPhoto.Co.UK at Cheltenham Film Studios in the English Cotswolds in 2005, moving from a home studio. Cheltenham, population 100,000, is about sixty miles west of London. Simon's studio includes numerous sets and an extensive adjacent garden. He enjoy creating high-color and high-contrast images that excite viewers. He also does film and TV, CD covers, and weddings. To learn more, please visit www.filmphoto.co.uk.

Describe your background.

At Exeter University I dabbled in art photography, but my career goal was in information technology. In 1995, I became involved in web design and graphics, and the computer unleashed my untapped artistic creativity.

My wife, Ingrid, inspired me to work at improving my concepts and techniques. I photographed her often, and worked to improve my digital manipulations. The local

camera club gave me a good boost in understanding why images work. In 2003, I started advertising as a portrait photographer in a converted garage, and I went to workshops. Let's face it: it's not hard to learn photographic theory if you master one main aspect: how shall I direct the light?

In 2005, I moved to a much larger studio in our nearest town, Cheltenham, happily continuing my photography career. I concentrate on people photography, and hearing, "Oh wow! Don't I look wonderful?" is my big thrill. Portraiture, model portfolios, and wedding photography dominate my time equally, but I also do fashion, film, theater, and events. I'm fascinated by how emotions are captured with a camera.

Who are your influences and mentors?

Two artists inspired me. Willi Kissmer makes photo-realistic engravings, many quite erotic without nudity. Form is revealed through cloth drapes. Howard Schatz creates stunning underwater images with humor and perfect composition.

To discuss and develop photography I joined a group of four local photographers whose work I respect. I'm a great believer that the person behind the camera is the most important part of the process. A thinking photographer will always find something extra through intuition, experience, and inspiration.

Describe your studio.

It's 1,000 square feet including 600 square feet of shooting area, plus office and storage space. In the UK it's

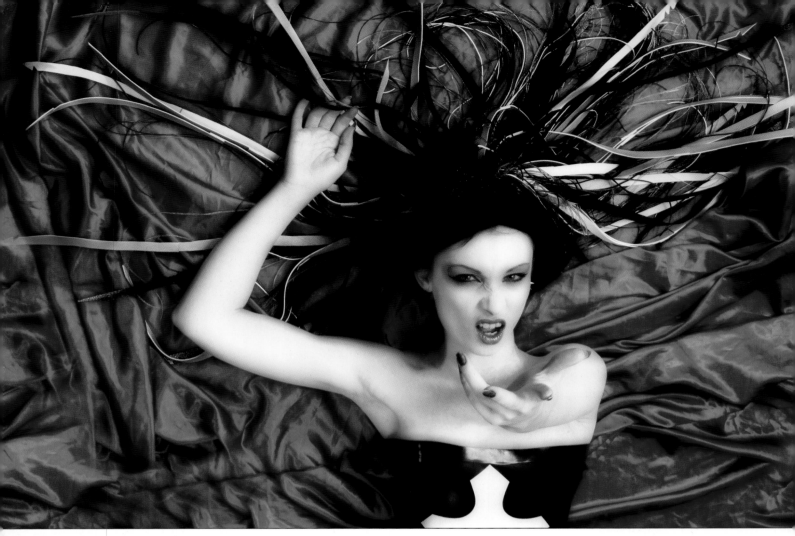

a large and expensive chunk of real estate. In the shooting area are a large white backdrop, a black backdrop, a mock castle wall, and a mock Mediterranean wall as permanent fixtures. I like a minimum of furniture—two chairs, and one settee on wheels. I nearly always work alone, though I bring in makeup artists when required.

The studio is situated in lovely grounds with a lake, woods, rocks, sculptured gardens, and a manor house that I can use as background. Most of my sessions are both indoors and outdoors, which gives me an edge in the UK, where few studios do outdoor work. I lease now, but I will buy when I find the right property. Real estate is very expensive, but commitment to a large monthly bill can be a strong business driver.

How do you approach your sessions?

What I want from every session are images that truly capture the individual spirit, and with some subjects that is not always feasible. Some clients only want a formal traditional style. Others seek something more dynamic.

You have to believe the client chose you because of your style, your distinctive touch. They may say simply, "I like your photos," and your enthusiasm must show. There's nothing clever about simply taking a photograph. A teenager running the shopping mall baby photo booth proves that. I set out in each session to create unique works of art.

Describe your approach to scheduling.

I try to schedule only a single portrait shoot a day, and if time allows I move to editing when the shoot is finished, though I have to be flexible. I never do more than one wedding in a day. Weekends are kept clear for Ingrid and me except for weddings and big group pictures. Meeting clients' needs often makes spontaneity necessary.

I also make time to take pictures for myself, for the fun of being creative. I'm fortunate to do quite a lot of model portfolios, so I can talk subjects into doing something different to explore my vision and give them something special too.

Were your early business expectations realistic?

There's a difference between realistic expectations and actually managing your business to achieve goals. In my transition from designing web sites to photography, I found that time is precious and needs to be focused. Most business owners discover that administration uses up too much time.

I found I had to do more marketing, more than just advertising. I make opportunities to network with people who can bring me business through word of mouth.

How do you approach posing?

I rely on standard poses until I feel a sitter is capable of something more. The usual poses offer a lot of comfort value and will produce reasonably attractive images. If the portrait subject is outgoing, I try more and different poses. Be flexible. Realize the client's personal well-being helps dictate where the session goes.

I begin with a subject seated on a chair, and shoot some easy and fairly formal poses. When the subject is more at ease I'll photograph them standing and moving from place to place, saying, "Stand against the wall, sit on the floor, be casual on the sofa." I like to shoot quickly and keep the energy and fluidity going. I also encourage numerous clothing changes.

I recommend working hard to practice posing clients. Your direction should be instinctive enough to avoid the client feeling you think he or she is fat. If a pose doesn't work, it's your fault. The client can't see what you see, so be positive. Straighten the subject's back "for a great body line," not "to make you look less heavy."

For most clients, I work around three core styles. The first is straight and formal, often on a white or mottled background. The second is a high-contrast, richly colored look for maximum impact. The third is a moodier, more romantic look, colorful, but with plenty of shadow around, and sometimes on, the subject. This style often comes with a soft focus treatment for emphasis. I rarely work with props unless there is a pictorial reason.

I believe experimenting is fundamental to your imagery. Whenever possible I experiment, trying a lighting style or an offbeat pose. Most experiments are variations

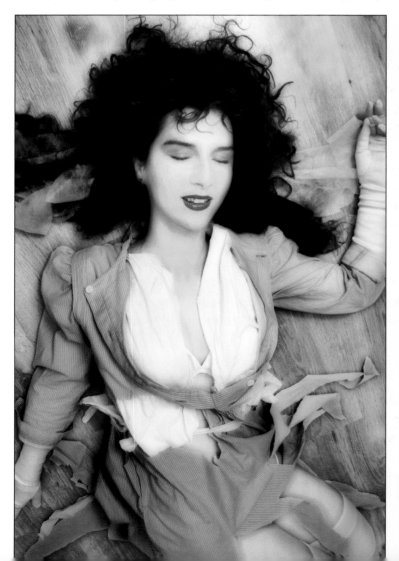

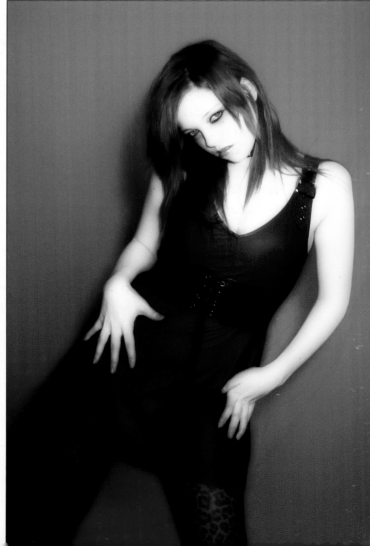

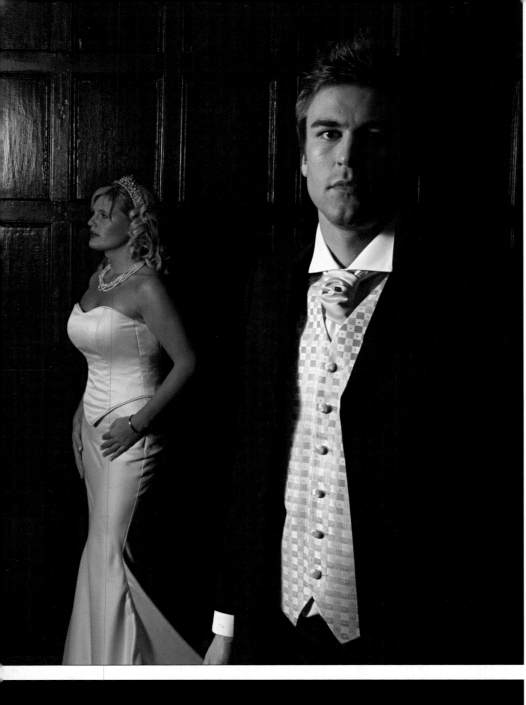

of themes, such as moving lights or adding or removing them, or doing something with reflectors. These can all be incorporated into a session.

What strategies do you employ to communicate with your subjects and elicit the desired expressions?

I'm not naturally a big talker but I try, mostly saying, "good, excellent, brilliant, well done." If I want a spontaneous expression, I ask the subject to shake their head, give it a twirl, or even jump up and down. I start a session with these top tips for posing like a supermodel:

- Place weight on the back leg and tilt your hip.
- Turn hands side-on to avoid "banana fingers."
- Lean forward to look more interesting.
- Don't lean on a hand posed near the face; delicately touch it to face.
- Straighten your back, pull tummy in, chest out (often repeated).
- Find a genuine laugh inside to express itself in a smile.

The last tip is most crucial. When they are smiling inside it really does show in the image. For most poses I show how I want them to look. To move the face I suggest, "Lift your chin a little, turn to the right a little."

What lighting equipment and approaches do you favor?

I use a maximum of three lights. My main light is a 2-meter octobox soft-light, and it's my friend. Turn it square on for good even beauty

lighting, flip it round to the side for a nice feathered but modeled light. My second light has either an umbrella or a tight reflector with a grid and is used for fill and spot lighting. My third light is permanently fitted with a beauty dish (a larger soft lighting reflector) that illuminates the backdrop, or is a hair light/backlight. For added interest I drop colored gels over the lights.

I start a session with the big octobox almost directly on the subject to ensure a well-lit face. Moving it to the side brings out more modeling. I position the subject so the lit side of the face is turned away from the camera to give it a thinner, more elegant structure.

Currently, I'm using more backlighting on the subject to enhance an image, which clients feel looks "professional" in the final image. Of course it helps separate the subject from the background and adds a glamorous touch.

Outdoors I nearly always shoot with a dedicated flash, either on-camera or on a flexible extension I can hold.

This adds a bit of fill and sparkle. In interesting lighting conditions the flash is turned off. I do most location photography in my garden at the studio where I know how the light works, and which backgrounds are the most useful.

On indoor locations I shoot without flash, using the camera's ISO adjustment to compensate for low light levels. I use image stabilized lenses, though I throw in a lot of motion blur or camera shake images. For indoor location fashion shoots my full studio lighting rig comes into play. I also take a complete portable studio to wedding receptions for guest portraits using a single umbrella light against a simple white backdrop. Photography is easier with happy and slightly intoxicated guests, uninhibited and smiling.

Which cameras and lenses do you prefer?
I use the Canon 30D with a 24–75mm IS zoom lens, and I switch to a long zoom 70–300mm for some outdoor

work. I feel that if you're a good photographer, you'll take good pictures with almost any kind of professional kit.

Do you sell many black & white prints?

Clients are presented with all their images in color and monochrome. I encourage them to go for the monochrome, which I feel is nearly always a longer-lasting image and more artistic. But clients often choose color because of its impact.

Describe your workflow.

I do all my own editing and enhancing using a whole set of sequences and custom-built filters. Most editing is cleaning up facial blemishes, flyaway hairs, marks on the floor, etc. My photographic style, in the shoot and in the final prints, is based on the images being digitally processed. I use Paint Shop Pro, which in some circles is seen as budget software, but it has a very customizable interface, and I've built a program that does what I want quickly and easily.

Almost everything is recorded as a script (equivalent to actions in Photoshop), so I can pull many different styles of finished images out at the click of a button. My sequence of operations produces a particular style, such as a sepia tone, or complex multilayered actions to create unique images. Even with discipline I usually find I have chosen too many pictures for the final edit, which I realize extends postproduction time.

I hate printing. Every printer I've ever owned has been a

pain; the paper misfeeds, the inks run out, it's too slow. So I upload images and order from a professional lab. It's simple and grief-free.

How are your clients' images presented?

At my studio clients see their pictures projected on a screen. Sometimes I send them a CD with a slide show presentation or put their pictures online. The best sales

come from presentation in the studio, where clients always choose more pictures and larger prints.

A CD slide show includes my sequence of images in color and black & white set to music to create an impact when they first see them. The CD is only active for fifteen days, but they can purchase a permanent CD or DVD.

How do you structure your pricing?
Here's how I see pricing: you are selling your time and expertise, and the client is buying prints. Perhaps we

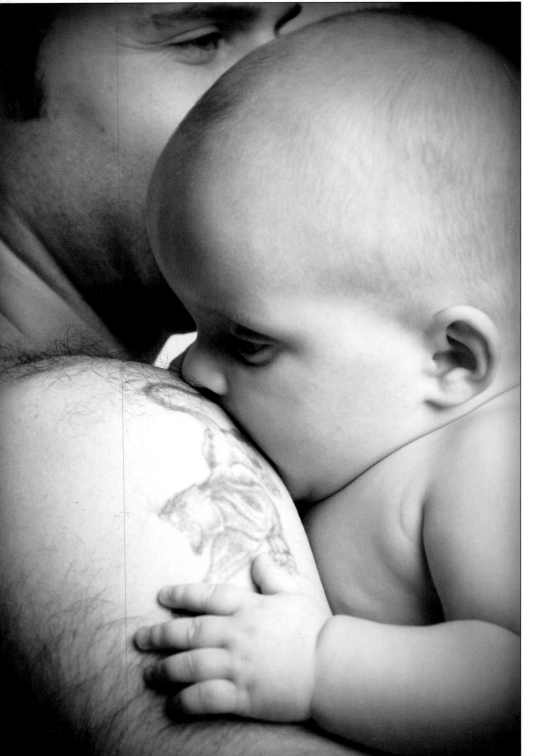

ought to charge on the basis of shooting and postproduction time. In my experience, when some clients first call they say they want one picture. By the time they finish they buy several prints, larger than they expected.

So, when a client first inquires, I'd like to say, "It's £X pounds for the whole shoot, and your prints are free." X is a large number representing what my work is worth. What the client wants to hear is that prints cost a small number. I have not been brave enough to do this, but I want to. I have not yet generated enough word of mouth among high-end clientele. In the meantime, my shoots are free and prints are in the medium price range. This has been successful in that the client is encouraged to make an appointment, and if they don't like my work, they've spent nothing, though that's happened only once.

I offer packages to models or actors for portfolios at a fixed price for a limited shoot with selected images on CD for them to print or e-mail. Models are looking for a range of pictures for different purposes than clients who put them on a wall.

How do you promote your studio?
Yellow Pages, my web site, and word of mouth are equal providers of new business. My company name is my web address: www.filmphoto.co.uk. Prospective clients decide if my work suits their tastes, and more importantly, decide if my pictures impress them more than my competitor's. I build and maintain my own web site—that's my previous career. I also send a regular newsletter to past and prospective clients, with special offers and vouchers.

Are there any business details you'd like to share?
I don't pay myself a fixed salary. My overall income is a part of the busi-

ness plan. My new, larger studio took me away from my old customers, so it's like building a new business with variable income. I don't employ staff; instead, I use freelance makeup artists or models when I need them.

New portrait photographers must consider marketing expenditures. Some opportunities that seem tempting will generate no income. Be budget conscious, but be prepared to spend more than you expected.

How important is a photographer's personality to his or her success?

I'm not a very gregarious person, but I am social, polite, and presentable. I smile a lot throughout a session to help my clients feel they have my personal touch. When I am selling, I am factual. I help clients with prices and selections but never push sales. I know other photographers who sell very hard, and clients spend more, but they don't always feel happy about it.

To me a shoot is like a jazz improvisation. Jazz musicians know that great music comes through practice. Great musicians practice incessantly to revisit old tech-

niques and learn new ones. They keep their fingers and minds supple. Photographers are also aware that improvisation is based on practice.

CONCLUSION

As you look through this book, you will find all kinds of portraits. Some are formal, some are candid, some are informally posed—and while no contributing photographer shoots just one type, each has a style and vision that is uniquely their own. How they have developed this style varies from photographer to photographer. Some look to comtemporary portrait artists for inspiration, others look back to the great portrait painters.

For my part, I would encourage you to study the work of the great pre-digital portrait photographers when searching for ways to enhance and expand your repertoire. Study the work of Joseph Karsh, who had a very successful way with celebrities and world figures. His lighting techniques might have been a bit formulaic for contemporary tastes—but what a formula!

Another terrific portrait photographer I'd recommend studying is David LaClaire. Although he is no longer practicing, David did a book of his own (self-published), a beautiful compendium of a life's work starting with his father's early 20th-century photographs. David developed an affluent clientele in Michigan and was also a friend of President Gerald Ford, whom he photographed often. His classic imagery is just what his rich clients wanted—and just what he loved to do.

Maybe I'm just nostalgic about classic portraiture. If so, it's just a counterpoint to the marvelous examples of more contemporary images that illustrate this book. Portraiture, in one form or another is as old as history. Make the most of it for yourself in your 21st-century business.

PORTRAIT OF MAN RAY BY LOU JACOBS JR.

INDEX